For Irving + Joan,
with best wishes,
Daniel

THE AMERICAN SPACE

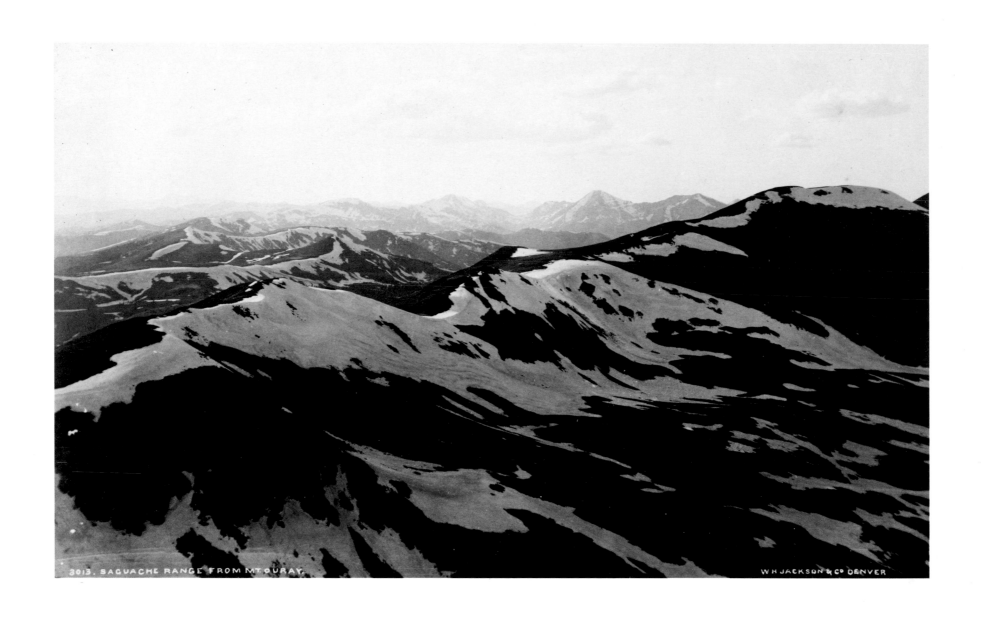

I WILLIAM HENRY JACKSON, PANORAMA FROM MOUNT OURAY, COLORADO, C. 1880

THE AMERICAN SPACE

MEANING IN NINETEENTH-CENTURY LANDSCAPE PHOTOGRAPHY

Edited and with Notes by
DANIEL WOLF

Introduction by Robert Adams

WESLEYAN UNIVERSITY PRESS Middletown, Connecticut

ACKNOWLEDGMENTS

I did this book for people to see that nature was once the essence of America.
I wish to express by indebtedness and thanks to all who helped: Robert
Adams, Bonni Benrubi, Eleanor Caponigro, John Coplans, Regina De Luise,
Lucy Freemont, Lori Gross, Jim Hughes, Joyce Kachergis, Diane Keaton,
Alan Labb, Phyllis Lambert, Ben Lifson, Willard Lockwood, Lisa McDonald,
Cynthia Miller, Dr. Melvin Moore, Weston Naef, Richard Pare, Peter
Palmquist, Nessia Pope, Fred Richen, Aaron Rose, Jessica Rose, Stephen
Rose, Robert Sobiezsek, John Szarkowski, Andy Szegedy-Maszak, Maggie
Taylor, Tiana Wimmer, Allen Zindman.

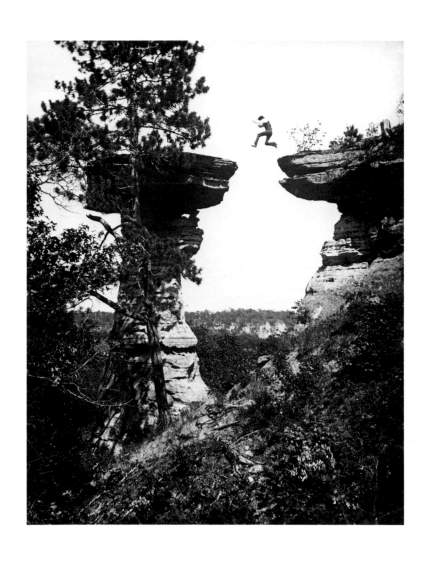

For my father who

made it possible to work

with intuition

and hope.

CONTENTS

LIST OF PLATES ix

INTRODUCTION I

PLATES

NATURE

Space	6–18
Rocks	19–30
Trees	31–40
Waterfalls	41–48
Light	49–55

MAN AND NATURE

Indians	56–61
Man and Space	62–83
Trains	84–93
Growth	94–110

NOTES ON PHOTOGRAPHERS 119

PHOTOGRAPHIC PROCESSES 121

SUGGESTED READING 122

LIST OF PLATES

The 108 photographs collected for *The American Space* were taken by some twenty-two amateur and professional photographers between the years 1842 and 1906. Most are of the West—Yosemite and Yellowstone, the Colorado and Columbia rivers, Utah, Idaho, New Mexico, Arizona, and California—but included are photographs of Brooklyn and Rochester, New York, and New Hampshire. The majority of the prints are albumen; but this collection includes daguerrotypes, platinum prints, platinotypes, and bromide prints.

Unless otherwise noted, all photographs are in the collections of Daniel Wolf.

PLATE 1 William Henry Jackson, Panorama from Mount Ouray, Colorado, c. 1880, 5″ × 7″, albumen print

PLATE 2 H. H. Bennett, untitled (Wisconsin Dells), 1885, 2″ × 2″, albumen print, collection of H. H. Bennett Studio

PLATE 3 Carleton Watkins, View of Merced River, Yosemite, California, No. 86, c. 1866, 15⅝″ × 20⅝″, albumen

PLATE 4 Samuel Bemis, untitled (vicinity Crawford Notch, New Hampshire), c. 1841, 6″ × 8″, daguerreotype, collection of Samuel Wagstaff

PLATE 5 Carleton Watkins, No. 423, Multnomah Falls, Columbia River, Oregon, c. 1867, 20¼″ × 15″, albumen print

NATURE

SPACE

PLATE 6 Carleton Watkins, The Domes from Sentinel Dome, Yosemite, California, 1866, 16¼″ × 20½″, albumen print, collection of Dr. Melvin Moore

PLATE 7 Carleton Watkins, The Lyell Group and Nevada Fall from Sentinel Dome, 1866, 16¼″ × 20½″, albumen print

PLATE 8 Carleton Watkins, Merced Group, from the Sentinel Dome, Yosemite, California, 1866, 16¼″ × 20½″, albumen print, collection of Dr. Melvin Moore

PLATE 9 Carleton Watkins, First View of the Yosemite Valley, California, from the Mariposa Trail, c. 1866, 16¼″ × 20½″, albumen print

PLATE 10 Carleton Watkins, Yosemite Valley, California, from the 'Best General View,' c. 1866, 16⅛″ × 20½″, albumen print

PLATE 11 Attributed to William Henry Jackson, Yellowstone Lake—Man's Bay, Wyoming, c. 1880, 16¾″ × 21⅛″, albumen print

PLATE 12 F. Jay Haynes, No. 3121, Yellowstone Lake, Mount Sheridan, Wyoming, c. 1885, 17⅛″ × 21⅞″, albumen print

PLATE 13 Carleton Watkins, Mount Shasta from Shasta Valley, California, c. 1870, 15¾″ × 20⅝″, albumen print

PLATE 14 Carleton Watkins, No. 452, Mount Adams, from Sunset Hill, Dalles City, Oregon, c. 1867, 15⅞″ × 20⅝″, albumen print

PLATE 15 C. P. Hibbard, No. 103, Sunrise on Mount Washington, New Hampshire, c. 1890, 7⅜″ × 9⅜″, albumen print

PLATE 16 T. E. M. & G. F. White, New Bedford, Massachusetts, c. 1900, 7½″ × 9½″, platinum print

PLATE 17 William Bell, Expedition of 1872, Colorado River Series, Plateau, North of the Grand Canon, Arizona, 1872, 9″ × 7⅛″, albumen print

PLATE 18 Timothy O'Sullivan, Canon of the Colorado River, near Mouth of the San Juan River, Utah, 1873, 8¹⁵⁄₁₆″ × 10¹³⁄₁₆″, albumen print

ROCKS

PLATE 19 Carleton Watkins, Cape Horn, Columbia River, Idaho, 1867, 20½″ × 15¾″, albumen print

PLATE 20 H. H. Bennett, untitled (Wisconsin Dells), c. 1880, 21½″ × 17¼″, albumen print

PLATE 21 Carleton Watkins, Seal Rock, Oregon, c. 1870, 21³⁄₁₆″ × 15⅞″, albumen print

PLATE 22 Adam Clark Vroman, Log in Bluff, Arizona (H. E. Hoopes album), August 1902, 5³⁄₁₆″ × 2¹⁵⁄₁₆″, platinotype

PLATE 23 William Henry Jackson, No. 1325, Mount Shasta from Sissons, California, c. 1870, 21″ × 17″, albumen print

PLATE 24 William Bell, Perched Rock, Rocker Creek, Arizona, 1872, 10¾″ × 8″, albumen print

PLATE 25 Carleton Watkins, No. 425, Castle Rock, Columbia River, Oregon, c. 1867, 15¼″ × 20½″, albumen print

PLATE 26 Carleton Watkins, Agassiz Rock, California, c. 1870, 18½″ × 15¼″, albumen print

PLATE 27 Carleton Watkins, Cathedral Rocks, Yosemite, California, 1866, 16⅛″ × 20½″, albumen print

PLATE 28 William Henry Jackson, No. 1064, Navajo Church near Fort Wingate, New Mexico, c. 1880, 16¾″ × 20½″, albumen print

PLATE 29 Carleton Watkins, Cathedral Rocks, No. 21, 2,600 feet, Yosemite, California, 1866, 15¾″ × 20⅝″, albumen print

PLATE 30 Carleton Watkins, Nevada Fall and Butte, California, c. 1870, 15¾″ × 20¾″, albumen print

TREES

PLATE 31 Thomas Houseworth and Co., The Three Graces, California, 272 feet high, c. 1875, 13⅛″ × 10″, albumen print

PLATE 32 Carleton Watkins, Sequoia Gigantea Decaisne, Sequoya was a Cherokee Indian, c. 1866, 21″ × 25½″, albumen print, collection of Jonathan Stein

PLATE 33 Carleton Watkins, Ponderosa, Yosemite, California, No. 48, c. 1870, 20¾″ × 15⅞″, albumen print

PLATE 34 Carleton Watkins, Cathedral Spires, California, c. 1866, 20½″ × 14¾″, albumen print

PLATE 35 Carleton Watkins, California Sequoia Giganta 'Grizzly Giant,' Mariposa Grove, No. 110, 1866, 20½″ × 15″, albumen print

PLATE 36 Carleton Watkins, Amanules, California, No. 78 (?), c. 1870, 20¾″ × 15⅞″, albumen print

PLATE 37 Carleton Watkins, Rosetree and Orange Grove, Residence of Governor Stoneman, California, c. 1880, 15¼″ × 21½″, albumen print, collection of Weston Naef

PLATE 38 Timothy O'Sullivan, Cereus Giganteus, Arizona, 1871, 10¾″ × 8″, albumen print

PLATE 39 Carleton Watkins, untitled (tree), c. 1870, 15⅜″ × 20⅜″, albumen print

PLATE 40 Carleton Watkins, Yucca Draconis, Mojave Desert, California, c. 1880, 20¾″ × 17⅞″, albumen print, collection of Weston Naef

WATERFALLS

PLATE 41 Eadweard Muybridge, Pi-Wi-Ack (Shower of Stars), Vernal Falls, 400 feet fall, Valley of the Yosemite, California, No. 29, 1872, 20½″ × 15⅞″, albumen print

PLATE 42 Eadweard Muybridge, Vernal Falls, Yosemite Valley, California, c. 1865, 20½″ × 15⅞″, albumen print

PLATE 43 F. Jay Haynes, Gibbon Falls, Yellowstone, Wyoming, c. 1885, 13″ × 10¼″, albumen print

PLATE 44 Carleton Watkins, Multnomah Falls, Columbia River, Oregon, c. 1867, 20¾″ × 15⅞″, albumen print

PLATE 45 F. Jay Haynes, Canyon of the Yellowstone, Wyoming, c. 1885, 17″ × 21¼″, albumen print

PLATE 46 F. Jay Haynes, Yellowstone Falls, Wyoming, c. 1885, 16¾″ × 21¼″, albumen print

PLATE 47 William Henry Jackson, No. 1086, Provo Falls, Utah, c. 1875, 16¾″ × 20½″, albumen print

PLATE 48 William Henry Jackson, Shosone Falls, Idaho, c. 1868, 21″ × 16⅞″, albumen print

LIGHT

PLATE 49 William Bell, Canon of Kenab Wash, Colorado River, Arizona, Looking South, No. 4, 1872, 10¾″ × 7⅞″, albumen print

PLATE 50 William Bell, Looking South into the Grand Canon, Colorado River, Arizona, 10¾″ × 7⅞″, albumen print

PLATE 51 Carleton Watkins, Mount Starr King, Yosemite, California, 1866, 20½″ × 16⅛″, albumen print

PLATE 52 Carleton Watkins, Mount Starr King, Yosemite Valley, California, 1866, 19¾" × 15¾", albumen print

PLATE 53 Carleton Watkins, El Capitan at the foot of the Mariposa Trail, Yosemite Valley, California, 1866, 15¾" × 20½", albumen print

PLATE 54 Eadweard Muybridge, Valley of the Yosemite from Rocky Ford, California, No. 4, c. 1865, 16¾" × 21½", albumen print

PLATE 55 William Henry Jackson, No. 1069, Grand Canyon of the Colorado, after 1880, 20¾" × 16¾", albumen print

MAN AND NATURE

INDIANS

PLATE 56 Ben Wittick, Hualpi Moqui Indian Village, Arizona, c. 1870s, 10⅜" × 13½", albumen print

PLATE 57 Ben Wittick, From the Top of Zuni, Arizona, Toh-i-Alli-ni (Thunder Mountain) in the distance. Toh-i-Alli-ni is the site of Ancient Zuni, c. 1870s, 10⅛" × 13½", albumen print

PLATE 58 Timothy O'Sullivan, Ancient Ruins, Canon de Chelle, New Mexico, 1873, 10⅞" × 8", albumen print

PLATE 59 Adam Clark Vroman, Acoma from Church Tower, New Mexico (H. E. Hoopes album), August 1902, 5⅞" × 3⅞", platinotype

PLATE 60 ———— Howard, Minneconyon Sioux Village, Near Spotted Tail Agency, Nebraska, c. 1868, 8¼" × 11", albumen print

PLATE 61 ———— Howard, Sioux Village on White River, c. 1868, 8¼" × 11", albumen print

MAN AND SPACE

PLATE 62 C. L. Weed, The Valley, from the Mariposa Trail, California, c. 1865, 16¾" × 19⅝", albumen print

PLATE 63 William Henry Jackson, No. 1006, Balanced Rock, Garden of the Gods, Colorado, c. 1880, 16¾" × 21", albumen print

PLATE 64 D. W. Butterfield, Profile House and Echo Lake, Franconia Notch, White Mountains, New Hampshire, 1883, 17⅜" × 21¾", albumen print

PLATE 65 William Henry Jackson, North from Berthoud Pass, Colorado, c. 1875, 7¼" × 4⅜", albumen print

PLATE 66 A. J. Russell, No. 65, Smith's Rock, c. 1870, 8¹⁵/₁₆" × 11¹⁵/₁₆", albumen print

PLATE 67 William Henry Jackson, No. 307, North from High Rock, c. 1870, 21" × 16⅞", albumen print

PLATE 68 Anonymous, untitled (New England), c. 1880, 4¹/₁₆" × 7¼", albumen print

PLATE 69 Anonymous, No. 3047, Glacier Point, 3,201 feet, Yosemite Valley, California, 1887, 9½" × 7⅝", albumen print

PLATE 70 William Henry Jackson, No. 1007, Tower of Babel, Garden of the Gods, Colorado, after 1880, 21" × 16⅜", albumen print

PLATE 71 William Henry Jackson, Old Faithful Geyser, Yellowstone, Wyoming, c. 1870, 21" × 16⅜", albumen print

PLATE 72 Jack Hillers, Grand Canon, Colorado River, Arizona, c. 1875, 13¼" × 9⅞", albumen print

PLATE 73 C. L. Weed, The Vernal Falls, 350 feet high, Yosemite Valley, Mariposa County, California, No. 18, 1867, 20¼" × 15½", albumen print

PLATE 74 Timothy O'Sullivan, Men on Volcanic Ridge, c. 1868, 7¾" × 10½", albumen print, collection of Weston Naef

PLATE 75 Timothy O'Sullivan, Rock Carved by Drifting Sand, Below Fortification Rock, Arizona, No. 14, 1871, 8" × 10¹³/₁₆", albumen print

PLATE 76 Timothy O'Sullivan, Historic Spanish Record of the Conquest, South Side of Inscription Rock, New Mexico, No. 3, 1873, 8" × 10¹³/₁₆", albumen print

PLATE 77 Timothy O'Sullivan, Sage Brush Desert, Ruby Valley, Nevada, c. 1868, 7⅞" × 10¼", albumen print, collection of Weston Naef

PLATE 78 Carleton Watkins, No. 420, Cape Horn, Columbia River, Oregon, 1867, 16" × 20½", albumen print

PLATE 79 Timothy O'Sullivan, Desert Sand Hills near Sink of Carson, Nevada, c. 1868, 7¾" × 10½", albumen print, collection of Weston Naef

PLATE 80 Carleton Watkins, Sugar Loaf Islands and Fisherman's Bay, Farallons, California, c. 1870, 15¾" × 20½", albumen print

PLATE 81 Charles R. Savage, untitled (boat in lake), c. 1870, 7¾" × 9⅝", albumen print

PLATE 82 H. C. Peabody, untitled (New England coastline), 1889, 16¾" × 20¾", bromide print

PLATE 83 H.F. Nielson, American Niagara Falls, 1885, 15½″ × 18½″, albumen print

TRAINS

PLATE 84 Carleton Watkins, No. 455, Mount Hood and the Dalles, Columbia River, Oregon, c. 1867, 15¾″ × 20⅜″, albumen print

PLATE 85 William Henry Jackson, N. 1291, Dale Creek Bridge, Union Pacific Railway, c. 1870, 16¾″ × 21″, albumen print

PLATE 86 William Henry Jackson, Cameron's Cone from 'Tunnel 4,' Colorado Midland Railroad, after 1880, 21″ × 16⅜″, albumen print

PLATE 87 Anonymous, untitled (train), c. 1885, 4¼″ × 7⅞″, albumen print

PLATE 88 William Henry Jackson, Canon of the Rio Las Animas (Colorado), No. 1077, after 1880, 16½″ × 20⅞″, albumen print

PLATE 89 William Henry Jackson, 'The Loop' Near Georgetown, Colorado, c. 1885, 21″ × 16¾″, albumen print

PLATE 90 Anonymous, untitled (train), c. 1885, 5⅞″ × 7⅞″, albumen print

PLATE 91 Carleton Watkins, Cape Horn, Oregon, c. 1868, 15½″ × 20½″, albumen print, collection of Weston Naef

PLATE 92 William Rau, No. 675, Lower Genesee Falls, Near Rochester, New York, c. 1885, 17″ × 20¼″, albumen print, collection of Seagrams Corporation

PLATE 93 William Henry Jackson, No. 1018, Toltec Gorge from the Portal, c. 1880, 21″ × 16⅞″, albumen print

GROWTH

PLATE 94 John K. Hillers, San Francisco Mountains, c. 1872, 12½″ × 9½″, albumen print

PLATE 95 William Rau, No. 573, Wilkebarre, from Point Lookout, c. 1885, 17⅛″ × 20¼″, albumen print, collection of Seagrams Corporation

PLATE 96 Carleton Watkins, New Almaden, c. 1880, 15″ × 20⅛″, albumen print

PLATE 97 Carleton Watkins, No. 693, San Rafael, California, c. 1880, 15¾″ × 20½″, albumen print

PLATE 98 Carleton Watkins, The Town on the Hill, New Almaden, California, c. 1870, 15¾″ × 20⅝″, albumen print

PLATE 99 Timothy O'Sullivan, The King Expedition, Virginia City, Nevada, c. 1867, 8¾″ × 11⅜″, albumen print

PLATE 100 Darius Kinsey, Spruce, c. 1900, 14″ × 11″, bromide print

PLATE 101 Darius Kinsey, No. 1100, Cords Shingle Bolts—Mill Pond Scene, 1913, 11″ × 14″, silverprint

PLATE 102 Anonymous, G. F. Hommel Governor Marganand, Grand Street, Brooklyn, New York, c. 1890, 16⅛″ × 21″, albumen print

PLATE 103 Anonymous (Minnesota), untitled (house and sheep), c. 1880, 4½″ × 7¼″, albumen print

PLATE 104 William Henry Jackson, No. 1409, Cheyenne Falls, c. 1870, 21″ × 17⅜″, albumen print

PLATE 105 J. W. Black, untitled (safe on Franklin Street, Boston), c. 1868, 15⅞″ × 12⅝″, albumen print

PLATE 106 William Henry Jackson (Detroit Photographic Co.), Littleton, White Mountains, New Hampshire, 1900, 16½″ × 38¾″, albumen print

PLATE 107 George E. Lawrence, Ruins of Nob Hill in Foreground from Lawrence Captive Airship, 1500 feet elevation, May 29, 1906, 16⅛″ × 38⅜″, silverprint, collection of Weston Naef

PLATE 108–109 J. R. Moeller, Grand Island, Nebraska, 1885, 4⅜″ × 7″, albumen print, collection of the Centre Canadien d'Architecture/Canadian Center for Architecture, Montreal

PLATE 110 Anonymous, The Coming Metropolis, Sea Haven, Washington, c. 1880, 7⁷⁄₁₆″ × 9⁷⁄₁₆″, albumen print

THE AMERICAN SPACE

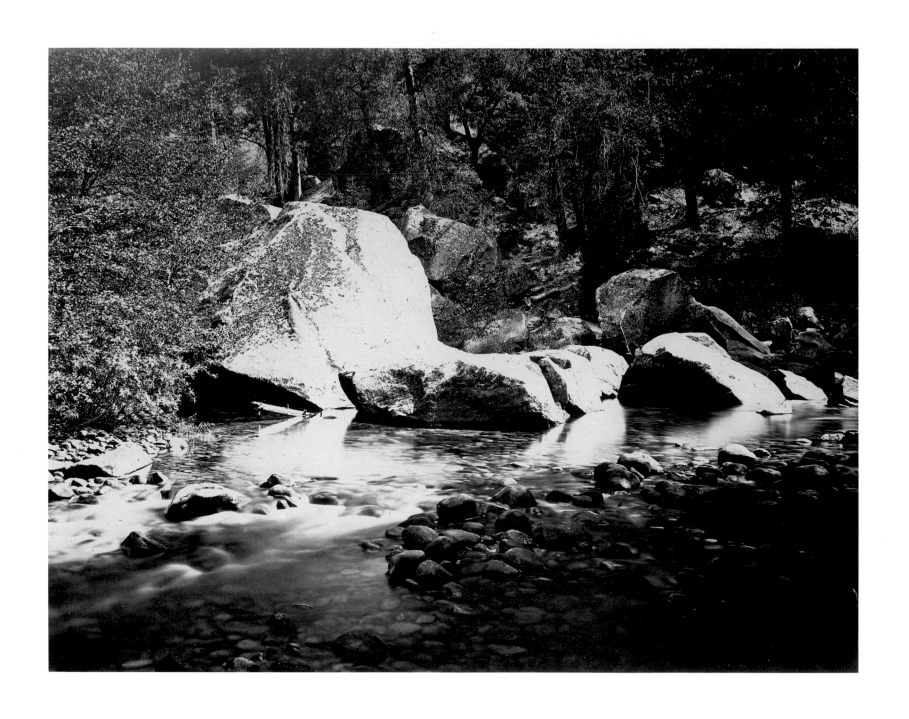

3 CARLETON WATKINS, VIEW FROM MERCED RIVER, YOSEMITE, CALIFORNIA, C. 1866

INTRODUCTION

We try hard not to be sentimental, not to feel more emotion for a subject than it deserves. Old pictures like the ones in this book are, however, sometimes cited as temptations. If the open America we loved is gone, then its recollection and the grief that inspires may be useless.

The force of this argument comes from our shock at the state of the current West. When else has a region of more than a million square miles been so damaged in so short a time? We catch ourselves thinking, in the bitterness that can accompany the unexpected sound of an aluminum can bending underfoot, that it would have been merciful if Columbus had been wrong and the world flat, with an edge from which to fall, rather than a circular cage that returns us to our mistakes. The geography seems hopeless.

It is true, admittedly, that the West has historically been filled in a series of sudden invasions, and that our present experience is in certain respects no different. The invasion that followed in the two decades after the Civil War—the time when most of these pictures were made—was itself facilitated as ours has been by new technology (theirs included such things as the invention of barbed wire and the completion of the transcontinental railroad). It was a period as well, like ours, of extraordinary brutality; John Muir observed, as did others, that "nearly all railroads are bordered by belts of desolation," perhaps referring to events like the killing of more than a million buffalo for their tongues alone. Even the junk the early intruders scattered forecast ours; a new

arrival to Denver in 1869 wrote that "the prairie is littered for miles with old tin cans and empty bottles."

What sets our recent experience apart, though, is first of all the scale of what has happened. It would not have been especially hard in the early part of this century to have retraced exactly the early photographers' travels, but by the 1960s and '70s one would have had to have been a confirmed trespasser; thousands of miles of roads were abruptly walled off by private property signs (meaning, often, corporate property), and even if one made it through to the photographers' vantage points one was likely to discover that their subjects were flat gone—the Salt Lake Valley under smog, many of the canyons under water, Shoshone Falls reduced to support irrigation, Mono Lake drained down the aqueduct to Los Angeles. Suddenly the size of the American space proved no defense.

The first useful thing of which the nineteenth-century photographs remind us is, I think, that space is not simple. We have tended to think it remained until we marked it off with fences or roads, or until we put buildings in it; if we could see to the horizon free of these things we assumed space remained. But as a short walk in the Southwest now often proves, it may be possible to see little but rabbitbrush for miles and yet know that the area is overpopulated.

Among the most compelling truths in some of the early photographs is their implication of silence. Western space was mostly quiet, a fact

suggested metaphorically by the pictures' visual stillness (a matter both of their subject and composition). What sound there was in front of the camera a hundred years ago usually came from the wind, though even that stirred few trees; running water appears in some of the pictures, but it was an exception; relative to the East there were not even many birds.

Now the noise level is far greater. The degree of change is demonstrated nearly everywhere, but I remember learning its complexity once as I photographed a remote church on the Colorado high plains; throughout the afternoon I studied the outside of the building from locations in the open fields to all sides, and alternately looked at the expanse from inside the church, through its simple lancet windows (one of the mysteries of space being that it sometimes seems bigger through a frame). At dusk I watched a line of clouds on the eastern horizon, white and rose, and then lightning far away in Nebraska, silent. In the morning, however, the place disappeared in sound. At first it had all seemed to be whole with the previous day; a coyote barked, the sun rose through a mist, and wildflowers opened. As I worked to set up a camera, though, there began and built to full volume in three or four seconds a noise of indescribable intensity; I turned to see a fighter plane, no more than two hundred feet off the ground and to the side of me, emerge from the haze and then disappear back into it, the heavy, terrible rush of its engine fading for many seconds out across the prairie. Eventually all was as quiet as it had been before, but the identity of the place, an identity dependent on the unbroken silence of space, was lost to me.

Another quality of space of which I am reminded when I look at the old photographs is the easy tempo of life in it—often space looks nearly unmoving—and by extension the tempo appropriate for anyone who hopes to experience space. The pinsharp views (how long did the photographer have to wait out the wind?), made only after establishing what amounted to a little camp in order to prepare the plates, and then taken only by substantial time exposure, suggest through the photographer's patience an appropriately respectful acknowledgment of the geologic and botanic time it took to shape the space itself. How can we hope, after all, to see a tree or rock or clear north sky if we do not adopt a little of its mode of life, a little of its time.

To put this another way, if we consider the difference between William Henry Jackson packing in his cameras by mule, and the person stepping for a moment from his car to take a picture with an Instamatic, it becomes clear how some of our space has vanished; if the time it takes to cross space is a way by which we define it, then to arrive at a view of space "in no time" is to have denied its reality (there are in fact few good snapshots of space). Edward Hoagland once observed that Walt Whitman would have enjoyed driving, which is surely true in the sense that he loved to see all he could so that he could assemble those long catalogues of his; after a few days at the wheel, though, I suspect Whitman's love of space might have brought him back to walking, since only at that speed is America the size he believed it. The poet William Stafford has written about the relation of time and walking to the settlement of open America, about

> Pioneers, for whom history was walking through dead grass
> and the main things that happened were miles and the time of day. [1]

Space does, it is true, occasionally have other speeds, as of antelope, which can run as fast as a car, if only for a brief while, but the common pace is more like that of tumbleweed, comic plants that wallop along at a rate we can usually match on foot (farmers on the plains have regrettably now found ways to strip wild growth from fence rows, denying us the plant's reminder of the velocity by which space is

[1]William Stafford, "Prairie Town," *Stories that Could be True: New and Collected Poems* (New York: Harper & Row, 1977), p. 70.

preserved). Little wonder that we, car-addicted, find the old pictures of openness—pictures usually without any blur, and made by what seems a ritual of patience—wonderful. They restore to us knowledge of a place we seek but lose in the rush of our search. Though to enjoy even the pictures, much less the space itself, requires that we be still longer than is our custom.

Another subtlety of space of which the photographs constructively remind us is the shaping, animating part played there by light. All landscapes are defined by the sun, but the intensity of the light in the West sets the region apart (Nabokov observed that only in Colorado had he seen skies—so clear that if one looks straight up they appear blue-black—like those of central Russia). The early photographers were limited in what they could show of variations in the sky, but they effectively suggested the power of light by juxtaposing bright, bleached ground against areas of deep shadow.

One remembers those pictures now, with their impression of arcing light, when one visits places like the bluffs above Green River, Wyoming, and sees there the numerous sources of aerial contamination that on some days make it look like the Ruhr, the sky dulled. Physically much of the land is almost as empty as it was when Jackson and Timothy O'Sullivan photographed there, but the beauty of the space— the sense that everything in it is alive and valuable—is gone. Exactly how this happens I do not think can be explained, any more than can the opening verses of Genesis about light's part in giving form to the void. But the importance of pure light is a fact for any photographer to experience; with it pictures of space are easy, and without it they are a struggle; though the difference between a clean sky and a smoggy one is not felt only by photographers. How emphatically absolute the distinction can be—we might at first suppose air pollution to be insubstantial and relative—was synopsized for me by the reaction of a woman who arrived in Denver in the 1960s to consider it as a home for her family; almost at once she phoned her husband who was working in Connecticut—he had been stationed in Denver during the Second World War—and said simply, referring to the landscape he had seen, "It's not here anymore."

Each of these aspects of space—its silence, its resistance to speed, and its revelation by light—seems to me usefully emphasized by the nineteenth-century photographs because even today there are fragments of the American space to be protected, and that is something that is more likely to happen if we are clear about the nature of what is threatened. The difficulty is, however, that we do not seem much to love the space that is left. One thinks not only of the greed of developers, which is numbingly obvious, but of a widespread nihilism that now extends through much of the population, witness the reflexive littering, the use of spray paint on rocks, the girdling of trees near campgrounds, and the use of off-road vehicles for the maximum violence of their impact. The West has ended, it would seem, as the nation's vacant lot, a place we valued at first for the wildflowers, and because the kids could play there, but where eventually we stole over and dumped the hedge clippings, and then the crankcase oil and dog manure, until finally now it has become such an eyesore that we hope someone will just buy it and build and get the thing over with. We are tired, I think, of staring at our corruption.

The sadness of this is, as the foregoing consideration of some of the qualities of space suggests, that areas of the American West are not wholly irredeemable. Though cities will not be unbuilt (some may disappear for lack of water), at least certain aspects of space, as suggested by the early pictures, could be partially restored—the land's quiet, its impression of size and stability when encountered slowly, and its sun-irradiated beauty. Some places could, in short, be emptied. We could control sound pollution by regulating the design of tires, by outlawing dirt bikes, and by restricting routes open to airplanes; we

could reduce the speed at which we travel through open country, not only by enforcing lower speeds on highways and waterways but by excluding motor vehicles entirely from whole areas; we could certainly better regulate light-impairing air pollution. Half damaged though the land is, we could keep what remaining space we have from shrinking, and perhaps even learn how, as the Japanese do with gardens, to make what there is seem, by our understanding care of it, bigger than it literally is, more spacious. At least there is no reason for a state like Kansas, with its ever-present horizon line, to seem small. Theodore Roethke described the peace that we might achieve:

> The fields stretch out in long unbroken rows.
> We walk aware of what is far and close.
> Here distance is familiar as a friend.
> The feud we kept with space comes to an end.[2]

The possibility of such a reconciliation, based on the fact that some of the American space is recoverable, is part of what keeps the pictures from being of only sentimental interest. To love the old views is not entirely hopeless nostalgia, but rather an understandable and fitting passion for what can in some measure be ours again.

The present condition of the western space does raise questions, nonetheless, about our own nature. When I think, for example, of Denver, I wonder if we can save ourselves. On grassland northeast of the city the Rocky Mountain Arsenal has buried in shallow trenches, without record of location, wheat rust agent made originally for germ warfare; the dump stands upwind of the American wheat bowl, and there is apparently nothing to prevent prairie dogs or a badger from someday opening it. To the west of the city, meanwhile, tableland has been so contaminated by fugitive plutonium from the Rocky Flats Nuclear Weapons Plant that developers have been forbidden to build

there, the space having been poisoned for many generations to come. If we can do these things—and they are not by any means isolated evils—are we capable of decent behavior? (It is a doubt that qualifies our enthusiasm even for the achievements of NASA.) Is what has happened to the West a matter for those social scientists who take a mechanistic view of man, or for theologians, who see us as moral beings capable of choice?

The best answer to this unanswerable conundrum seems to me to be the compromise offered by classical tragedy. The plays are convincing because they falsify neither side of our ambiguous experience, which is of both freedom and fate—freedom as we know the world to be more exciting than the monotonies of a naturalistic novel, and fate as we live in a world worse than anyone could have desired.

In the plays of Sophocles and Shakespeare the hero is shown to believe, in ignorant pride, that he is godlike, which is to say free, and to learn through suffering that his freedom is paradoxical—to accept limits. Although presumably the photographers who took the early landscapes did not intend such an analysis of our country, since they witnessed no more than the opening events, their pictures do lead us now to reflect on a tragic progression. They remind us of the opportunity the openness provided for the confusion of space and freedom, an understandable but arrogant mistake for which we all now suffer.

Space as we see it in the early pictures was not just a matter of long views, but also of distance from people. Many of the scenes are completely unpopulated, lacking any signs of man at all. Where there are figures they seem mostly to have been drafted from the photographer's party. And when there are buildings or railroads they often appear to have gotten the photographer's attention precisely because their presence was unusual.

In front of such landscapes it is easy to sympathize with those who lived out the early acts of our national misunderstanding of space. Little wonder that Americans said so confidently and unqualifiedly

[2]Theodore Roethke, "In Praise of Prairie," *The Collected Poems of Theodore Roethke* (New York: Doubleday, 1966), p. 13.

that they were free. How could they be otherwise—they were alone, or so it seemed. And they had gotten there as a result of their own effort. One of the striking things about many pioneer journals is that though the events described sound inexorable (disease, accident, failed crops), the feeling expressed is of having chosen the life. Even in accounts of river travel, where the course was set, there was a sense of liberty; Huck Finn, Twain's incognito, expressed it almost every time he shoved the raft away from the bank, and Major Powell, no matter how deep in the confines of some gorge, wrote as if he were carried along mainly by the engine of his own enthusiastic choice.

At its best this equation of freedom with isolation from others has been understood as liberty to know oneself. In the words of Rosalie Sorrels, the contemporary composer and singer, the West "is the territory of space . . . a place where people have gone so that they could hear the sounds of their own singing . . . so that they could hear their name if they were called . . . so that they could know what they think." It is impossible even now, even after our tragedy, not to admire the spirit of that. One wonders, for example, if Abraham Lincoln's character would have been the same had his family not been the sort to keep moving west as soon as they saw the arrival of neighbors.

A consideration of space and freedom and the American West begins logically, in fact, with the Civil War, a war about freedom (it also marks, conveniently, the starting point in America for serious, extensive landscape photography). A significant amount of the war was fought along the edge of the American space, and some even in it, as at Glorieta Pass, New Mexico. And the war's conclusion made possible the beginning of the great invasion of western space. Indeed, as has often been pointed out, had those who enacted the war not been allowed to migrate in numbers into the West it is hard to see how the hatreds would have cooled as they did.

George N. Barnard's pictures of holes blasted in the woods stand as frightening metaphors for what would follow the war; the bare ground and broken trees synopsize what was to be our violent assertion of our own space in space. As do all wars, the Civil War produced a generation of people tired of trying, of paying for ideals, and the condition of the West is to be explained in part by that generation's cynicism and the pattern it set. Many immigrants saw their separation from others as a welcome freedom from responsibility. Liberty meant leaving people, whatever their needs, behind. We became a nation of boomers, everlastingly after a new start out in the open, by ourselves.

This morally indefensible equation of space, understood as distance from others, and freedom, understood as license to pursue one's own interests without regard for those of others (no one else being in view), has ended of course in the reduction of everyone's freedom. As the apparently infinite number of opportunities to start again stretched away westward, the mythology of capitalism appeared plausible. Anyone could, if the compulsion of his greed were left alone by government, go into the space, which was luckily well stocked with natural resources, and by work become rich. Mounting evidence to the contrary has for the most part been censored out in public education and the press, both influenced by profiteers, until now things have gone so far that the space has nearly been denied us. Ironically, corporate capitalism has for a century been allowed such sway that it has now, in the name of economic efficiency, almost cleared the space of exactly the people who wanted to enjoy it—small farmers, miners, and ranchers. We are left an urban nation, one today largely prohibited even visiting rights to the country. We look back at the early pictures and marvel that the sheer size and beauty of the space could have absorbed and hidden for so long the damage done by unrestrained self-interest. Our destiny is to suffer the imprisonment of places like Los Angeles, with its twelve lane "freeways," though whether in this we have the courage to find self-knowledge remains unclear.

What is the relevance of these old photographs, then, to a country

that has enacted a tragedy, that has, in Roethke's words, "failed to live up to its geography"? Part of the answer is that the pictures tell us more accurately than any other documents we have exactly what we have destroyed. With the pictures in hand there is no escaping the gravity of our violence; the record is precise, as exact as the ruler O'Sullivan photographed against Inscription Rock in New Mexico.

What we are forced to see is that the West really was, despite all the temptations there are to romanticize the past, extraordinary—as extraordinary as the great flow of the Columbia River, the rock spires in Canyon de Chelly, or the deep space above the Sierra. The pictures make clear that before we came to it in numbers the West was perfect. The camera, as used by O'Sullivan and Jackson and Carleton E. Watkins and John K. Hillers, refutes every easy notion of progress, every sloppy assertion that we have improved things (early land promoters on the prairie actually argued that settlement would increase the rainfall!). When we look at what was there before us we are compelled to admit with the poet Cid Corman, "How obvious it is I couldn't have imagined this."

One way to judge the importance of the photographs is to compare them to paintings from the same time. Enough landmarks remain in something like their original form to check both photographers and painters against identical subjects, and with few exceptions the photographers come off better. I think, for example, of the painting now in the White House by Thomas Moran of the bluffs at Green River, a picture in which the sky seems derived from the English moors, lush and moist. It is a fiction, as are most of Moran's finished paintings, just as are those by Albert Bierstadt, the other celebrity painter of the time.[3]

There are in fact only a few accurate nineteenth-century western landscape painters—Karl Bodmer, John Henry Hill, Worthington Whittridge, and Sanford Robinson Gifford are the only ones I would care to defend—and for the most part they made their reputations elsewhere, their contact with the West having been brief and geographically narrow.[4] By contrast, photographic careers of lasting importance were built almost entirely in the West, and evidence a longer and wider acquaintance with the landscape.

Why painting, which earlier had flourished as a record of space along the eastern seaboard, succeeded so little in the West is a matter of speculation. The photographers may in some cases have been helped by the fact that their job was usually first to make a clear record for the War Department or the Geological Survey or the railroads; it was the sort of assignment to keep one moving and save one from pretense. But some of the painters were given similar priorities.

One suspects that the freshness of the photographic enterprise may have helped—the fact that there was a new way to see. Something at any rate appears to have built an enthusiasm that in turn contributed to endurance, and since the longer one is in a landscape, especially a spare one, the more one is likely to love it, it gave them an advantage, art being in the last analysis an affirmation, a statement of affection. Jackson, for instance, when he lost his job with the Geological Survey,

[3]It is true that many preliminary studies by Bierstadt and Moran are convincing, suggesting that part of the problem may have been the necessity of doing the finished paintings (which tended to be large) long afterward, far removed from the subject. The changes that the two made, however, were always additions in the direction of Wagnerian theatricality, and it is impossible not to conclude, when confronted by studies so uniformly better than the finished works, that the painters did not understand what they were doing; with Bierstadt and Moran we are reminded of Goethe's observation that "genius is knowing when to stop." Other landscape sketchers in the West, though perhaps not geniuses—men like Seth Eastman, John Mix Stanley, and Frederick Piercy—did usually content themselves with what they recorded on the scene, and thereby left us records of less ambiguous value.

[4]The finest landscape painter of the American wilderness in the late nineteenth century, Winslow Homer, never came west, and the great realist, Thomas Eakins, visited the West only one summer, leaving as his best record of the experience two photographs of cowboys. Of the other major painters whom one supposes might have dealt credibly with the American West, Frederic Church traveled extensively but never to the West, and John Frederick Kensett,

never seriously considered leaving the West: "Whatever I might find for myself," he wrote, "it must be in some great open country." Few painters were that committed to the place. The photographers were the ones who were in it for keeps, and who were intoxicated by some of the spirit of that ad for film (recorded by Steve Fitch) on the road to Grand Canyon—"Hit the Rim Loaded." It was fun. O'Sullivan is quoted, for example, as saying even of the desolate and mosquito-infested Humboldt Sink that "viewing there was as pleasant work as could be desired." One supposes that the spell-binding nature of photography led them on just as it does us—the fact that in one take you can get it all right down to the individual leaves on the sagebrush.

The chief reason the photographers did better than the painters, however, was that when the painters were confronted with space they filled it with the products of their imaginations, whereas photographers were relatively unable to do that. The limits of the machine saved them. If there was "nothing" there, they had in some way to settle for that, and find a method to convince us to do the same. Generally speaking the painters imposed Switzerland on the Rockies, for instance, producing western landscapes that were crowded rather than spacious; they turned mountains vertiginous, hung thick atmospheric effects on peaks and through valleys, and placed in the foregrounds camps and grazing animals. Though photographers could and did steepen the apparent grade of mountains, they could only imperfectly register clouds (some like Barnard tried to print in skies from second negatives that had been exposed specifically to record them, but the composite usually betrayed itself at the horizon), and they hadn't any chance at all, with their slow apparatus, of stopping camp activity or wildlife.

Nineteenth-century photographers of the West could not, in short, often bring landscapes to intense dramatic focus, as could painters, because they could not add to them. If the middle was empty, that was the way it had to be shown. (They could, of course, fill pictures with eccentricities like Shoshone Falls and El Capitan, but the meaning of these spectacles was ultimately to be found in the norm they exceeded, so that to concentrate on them exclusively would have produced a record as pointless as those tourist slide shows that unrelentingly take us to every spring and geyser in Yellowstone.) At their best the photographers accepted limitations and faced space as the antitheatrical puzzle it is—a stage without a center. The resulting pictures have an element almost of banality about them, but it is exactly this acknowledgment of the plain surface to things that helps legitimize the photographer's difficult claim that the landscape is coherent. We know, as we recognize the commonness of places, that this is our world and that the photographer has not cheated on his way to his affirmation of meaning.

Among the reasons for enjoying the experience of space is the proof it offers of our small size. We feel in its presence the same relief expressed by the man who in 1902 managed to drive his car—the first one ever—to the edge of the Grand Canyon: "I stood there upon the rim of that tremendous chasm and forgot who I was and what I came there for." It had apparently been one of those journeys away from oneself, in search of awe—a drive we still make.

Insofar as the western photographers were artists, however, their work helps us beyond a humbling realization of our small size to a conviction of our significance as part of the whole. We and everything else are shown, in the best pictures, to matter. The photographer's experience was, it seems to me apparent from the pictures, finally not just of the scale but of the shape of space, and their achievement was to convey this graphically.

What they found was that by adjusting with fanatical, reverential care the camera's angle of view and distance from the subject they could compose pictures so that the apparently vacant center was revealed as part of a cohesive totality. They showed space as itself an element in an overall structure, a landscape in which everything— mud, rocks,

brush, and sky—was relevant to the picture, everything part of an exactly balanced form.

Art never, of course, explains or proves meaning—the picture is only a record of the artist's witness to it. He or she can, however, be a convincing witness. In the case of these pictures we are helped to belief, I think, by the photographic approach—the views are mostly long shots that have been made with normal lenses (lenses that approximate the breadth and magnification of average human vision). It was a method that restricted the photographer's opportunities to control our view of the subject (his only ways substantially to alter the composition being to hike farther, or to wait or return for different light), but the sense of objectivity it conveys tends to neutralize our skepticism. It is obviously easy to assert that life is coherent, but to work out the visual metaphor for that affirmation from within the limits of an almost ant-like perspective is hard and remarkable. One is reminded of George Steiner's definition of classicism as "art by privation." What kind of art could be more convincing in the depiction of the Southwest, of the desert, of a landscape that is by common standards deprived?

To go beyond showing mere size to a demonstration of form is important because awe by itself, without an accompanying conviction of pattern, can easily give way simply to fear. Job was at last reconciled to life not by being shown only that he was small and therefore necessarily ignorant, but by being reminded of mysteries that are part of a creation in which all elements are subordinate to a design; the world, God tells Job, is a "vast expanse" but regulated by seasons, the heavens are immense but divided and given shape by stars like those in the Pleiades, and the oceans are an "unfathomable deep" but the appointed home for whales. By contrast it is an attention to size alone, at the expense of pattern, that makes so much romantic art so discomforting. One wishes romantics were compelled more often to live on the ocean or the prairie, where they could discover to what lengths the size of space might drive them. Ahab was fiction's hyperbole, of course, actually

doing battle with the inarticulate expanse, but his compulsion is there for any of us still to suffer, even if more passively. I think, for example, of a man on the Colorado prairie of whom I know, an ex-submariner who has relegated his orthodox house to storage and moved below ground into a roofed-over foundation, safely submerged.

To the extent that life is a process in which everything seems to be taken away, minimal landscapes are inevitably more, I think, than playgrounds for aesthetes. They are one of the extreme places where we live out with greater than usual awareness our search for an exception, for what is not taken away. How else explain, finally, the power of the best nineteenth-century landscapes of space except as they result from this struggle.

Timothy O'Sullivan was, it seems to me, the greatest of the photographers because he understood nature first as architecture. He was our Cezanne, repeatedly creating pictures that were, while they acknowledged the vacancy at the center (a paradoxical symbol for the opacity of life), nonetheless compositions of perfect order and balance. O'Sullivan's goal seems to have been, as Cezanne phrased it, "exciting serenity." Each was an artist/geologist, in love with light and rock.

O'Sullivan came to the convictions he expressed in his western pictures by way of experiences that must seem to us now especially relevant; he began by photographing war. Sometimes this involved taking shots of units behind the lines, like those of soldiers attached to the headquarters for the army of the Potomac, shown drawn up in ranks, and of a contingent of more than two hundred wagons and teams assembled perfectly into formation. On other occasions, however, he photographed in the midst of combat, as at Fredericksburg, or in the aftermath of combat, as at Gettysburg where he made among the most desolate pictures ever taken of war's results. In one such view he recorded a meadow littered randomly with bloating corpses; the head of the nearest tilts toward the camera, mouth agape as if caught mid-scream, while in the distance a living officer sits placidly on his horse, forecasting the

grandiose, dishonest statuary to come. Another picture shows bodies that have been dragged by a graves detail into a ragged line, a grotesque approximation of parade ground order.

Nietzsche observed that "whosoever has built a new Heaven has found the strength for it only in his own Hell," and this it seems to me must to some extent have been the origin of O'Sullivan's western landscapes. More than any of the other photographers O'Sullivan was interested in emptiness, in apparently negative landscapes, in the barest, least hospitable ground (he did little with the luxurious growth in Panama, where he visited briefly). Most of his pictures are of vacancies —canyons or flats or lakes, the latter rendered as silver holes reflecting the space of the sky. In them he compulsively sought to find shape, to adjust his perspective until the plate registered every seemingly inconsequential element in balance.

The uniformity of emphasis in such pictures—the overall order, but often without a dramatic center—has recommended them to some modern photographers and painters who see the world as nonhierarchical, and who therefore themselves photograph or paint in ways that emphasize all components equally. This bias had tended to obscure, however, what was for O'Sullivan, I suspect, a different goal—to counter the leveling confusion he witnessed in battle. It is hard in fact not to see the ambulance he used to carry his equipment through the West as a metaphor, though it obviously wasn't meant that way, for what appears to have been his wandering recovery from the disintegration he pictured at Gettysburg. Because the fact is that the landscapes he made in the West affirm with obsessive consistency an order larger than the one he saw blasted away, an order beyond human making or unmaking. The pictures themselves are human compositions, but they refer to a design that is independent of us.

O'Sullivan was, from what little evidence there is, a likable, outgoing man—apparently a storyteller, notoriously profane, and respected enough by his companions to be frequently put in charge. Despite his gregariousness, however, he made people his first pictorial concern only rarely. He may not have been skilled at portraiture, but one also suspects that by the time he got to the West people did not much interest him as photographic subjects—except, and it is an important exception, as their response to nature interested him. The best picture he made at the Zuni pueblo, for instance, was not directly of Indians but of their walled gardens at the edge of the desert. And among the finest pictures he ever took were those at Canyon de Chelly, a place where people had for centuries lived harmoniously in a reserve of rock. It is interesting to recall as background for those pictures, however, what O'Sullivan surely knew as he photographed there in 1873—that in January 1864, while the Civil War continued in the East, Kit Carson had led federal troops into the Canyon, and there killed or captured what Indians he found (they were starving and freezing) and as a final stroke ordered the destruction of some five thousand peach trees the Indians had lovingly tended on the canyon floor. Against these events O'Sullivan's landscapes, which are filled with light and stillness, stand as profound meditations.

It has been suggested, mostly on the basis of O'Sullivan's having worked for Clarence King's surveying expedition through the West, that O'Sullivan shared not only King's interest in the "catastrophes" recorded in western geology, but also his belief that the earth's history is determined by catastrophes. In such a reading the pictures (which do often show geologic upheavals, as are to be seen throughout much of the West) are ominous and any divinity responsible for them is hostile.

Though O'Sullivan certainly suffered the catastrophe of the war and thus might have been attracted to the topic in general, it seems to me doubtful that the pictures of the West were taken as an indictment of the nature of life. For one thing, the pictures he made of the war's casualties did that in a way so absolute that anything more was redundant. As for King's influence (and to a lesser degree that of George Wheeler,

O'Sullivan's other superior in the field), presumably they did talk philosophy around the campfire, but that does not itself establish what O'Sullivan, very much his own man, believed. The pictures are the only dependable evidence we have about that, and the persistent impression they give is of calm, of stasis, which does not really accord with a philosophy of turmoil. O'Sullivan undoubtedly pictured many things at King's request, but his treatment of the subjects suggests that the director of the project may not have understood what motivated the photographer (this kind of innocence is not unusual; Roy Stryker, who supervised photographers working for the Farm Security Administration in the 1930s, had, for example, little grasp of what one of the best of them, Walker Evans, was trying to do). It is worth adding, finally, a truism from the experience of many landscape photographers: one does not for long wrestle a view camera in the wind and heat and cold just to illustrate a philosophy. The thing that keeps you scrambling over the rocks, risking snakes, and swatting at the flies is the *view*. It is only your enjoyment of and commitment to what you see, not to what you rationally understand, that balances the otherwise absurd investment of labor.

Whether O'Sullivan's pictures and those of other nineteenth-century landscapists suggest a hostile universe comes down, I think, to expectations. If we require a world designed for us, then the West they pictured is threatening, even malevolent. Alternatively, however, we can try as they did to see the landscape from a less self-centered point of view, and perhaps find in that perspective some consolation.

Admittedly the pictures do not suggest that life will turn easy. Cezanne is himself reported habitually to have remarked that "life is fearful"; Mont Sainte-Victoire was, like much of the geography O'Sullivan photographed, a pitching mountain. The wonder of the paintings and photographs is, though, that in them the violent forms are brought still, held credibly in the perfect order of the picture's composition. Nothing is proven, but as statements of faith they strengthen our resolve to try to discover in our own lives a cognate for the artist's vision. In the case of O'Sullivan's vision, typified as it is finally by the intense quiet of Canyon de Chelly, we note how arduously it was earned, coming only by way of the scream at Gettysburg. O'Sullivan's western pictures are, to borrow a phrase from Roethke, the achievement of "a man struggling to find his proper silence."

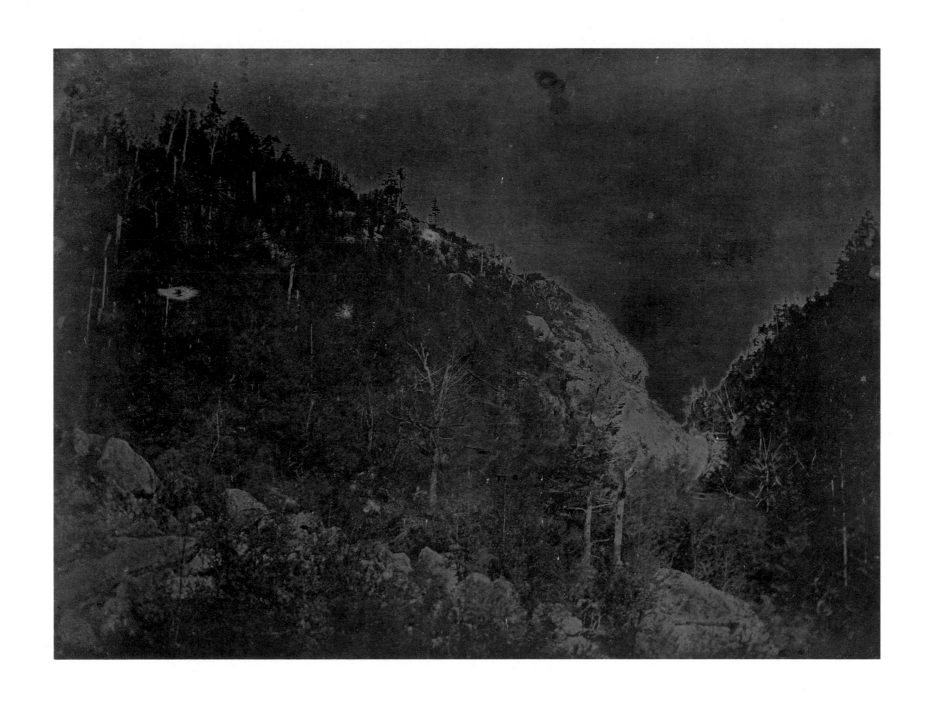

4 SAMUEL BEMIS, UNTITLED (VICINITY OF CRAWFORD NOTCH, NEW HAMPSHIRE), C. 1841

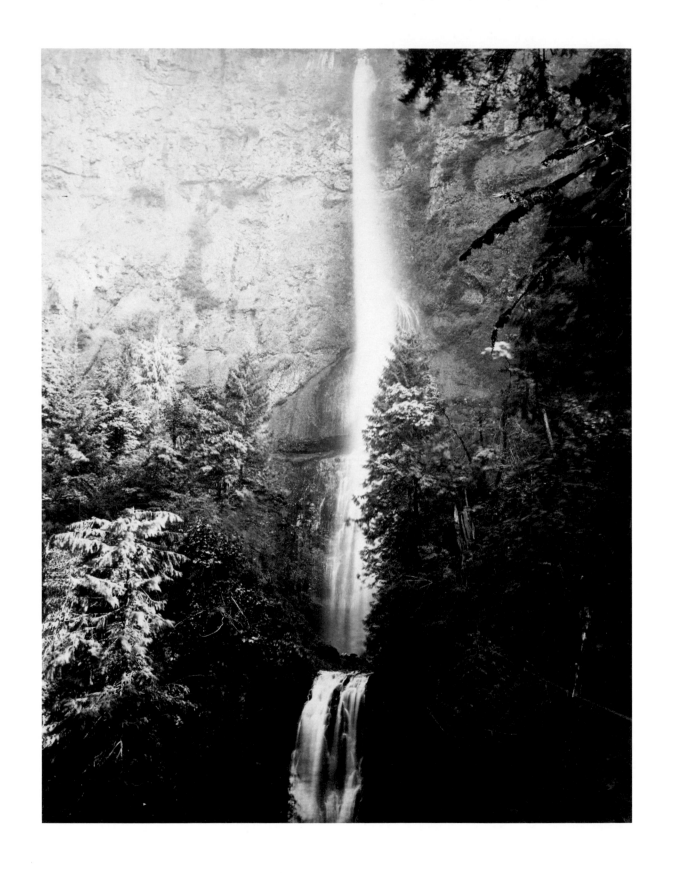

5 CARLETON WATKINS, MULTNOMAH FALLS, COLUMBIA RIVER, OREGON, C. 1867

NATURE

SPACE

ROCKS

TREES

WATERFALLS

LIGHT

6 CARLETON WATKINS, THE DOMES FROM SENTINEL
DOME, YOSEMITE, CALIFORNIA, 1866

7 CARLETON WATKINS, THE LYELL GROUP AND NEVADA FALL
FROM SENTINEL DOME, YOSEMITE, CALIFORNIA, 1866

8 CARLETON WATKINS, MERCED GROUP, FROM THE
SENTINEL DOME, YOSEMITE, CALIFORNIA, 1866

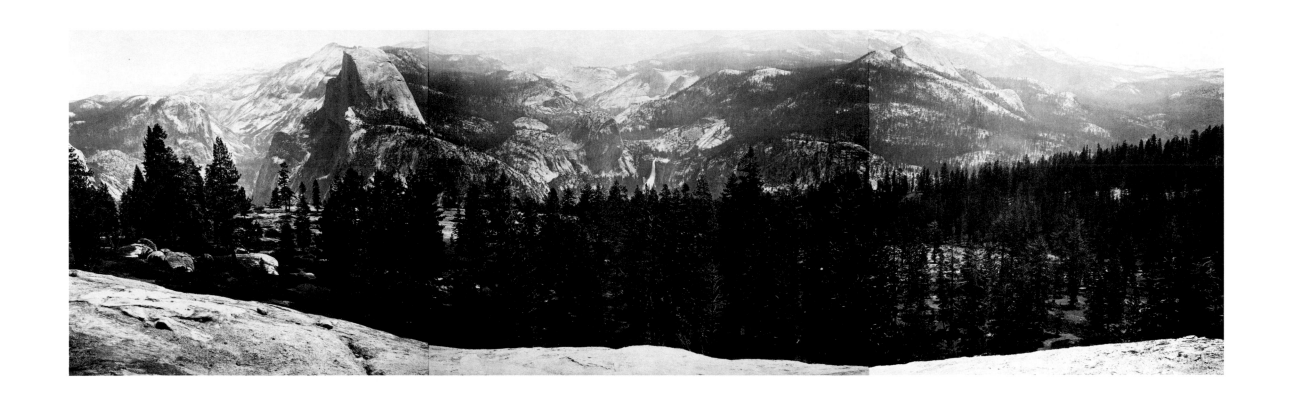

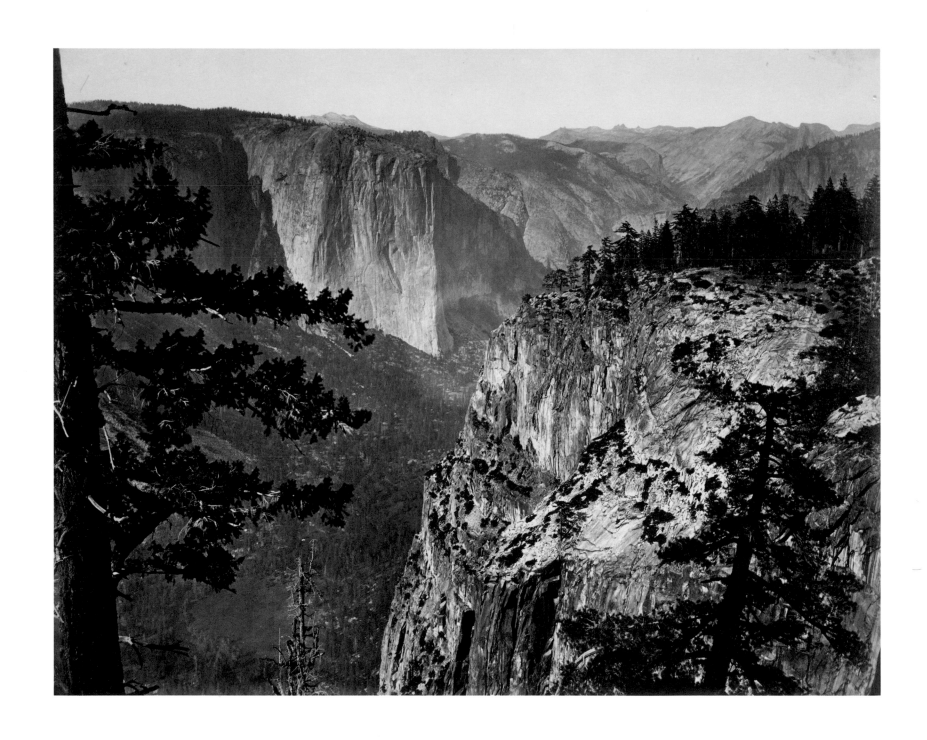

9 CARLETON WATKINS, FIRST VIEW OF THE YOSEMITE VALLEY, CALIFORNIA, c. 1866

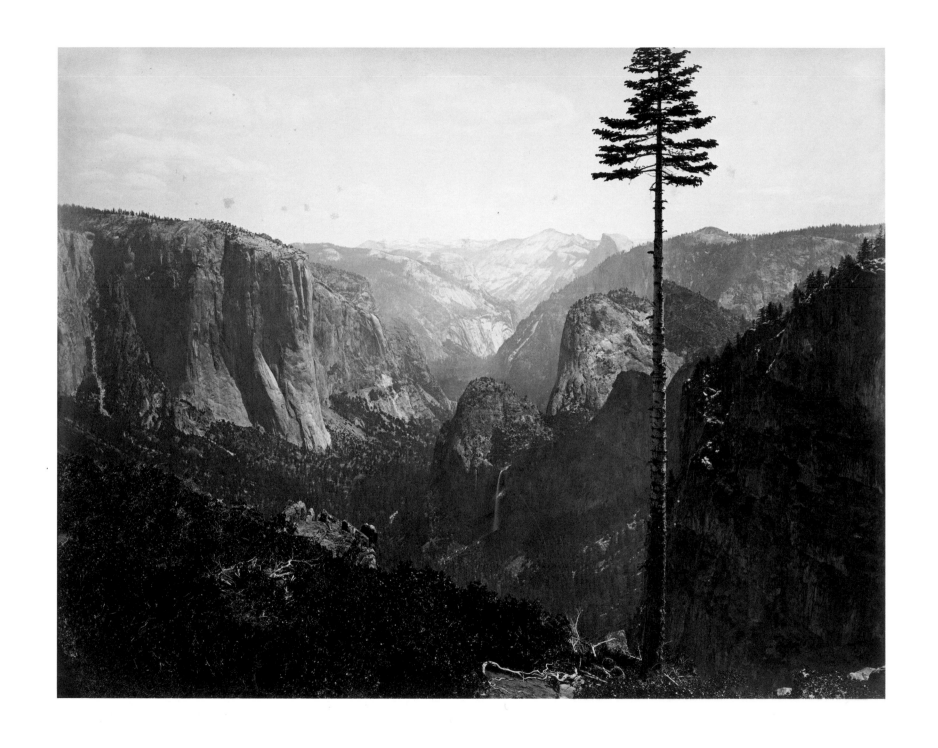

10 CARLETON WATKINS, YOSEMITE VALLEY, CALIFORNIA, FROM THE 'BEST GENERAL VIEW,' C. 1866

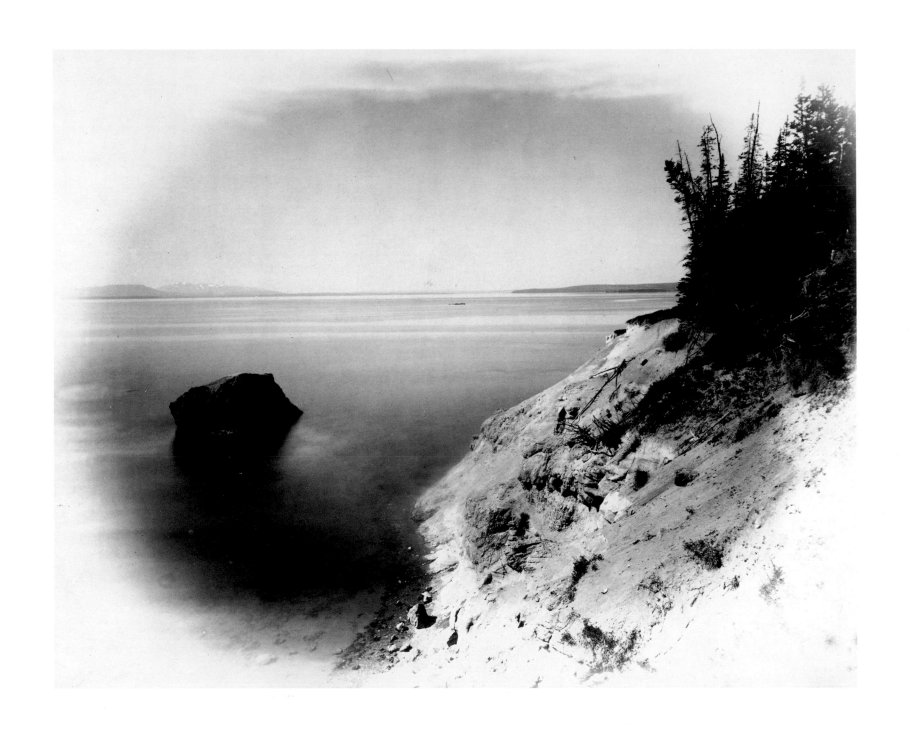

II ATTRIBUTED TO WILLIAM HENRY JACKSON, YELLOWSTONE LAKE — MAN'S BAY, WYOMING, C. 1880

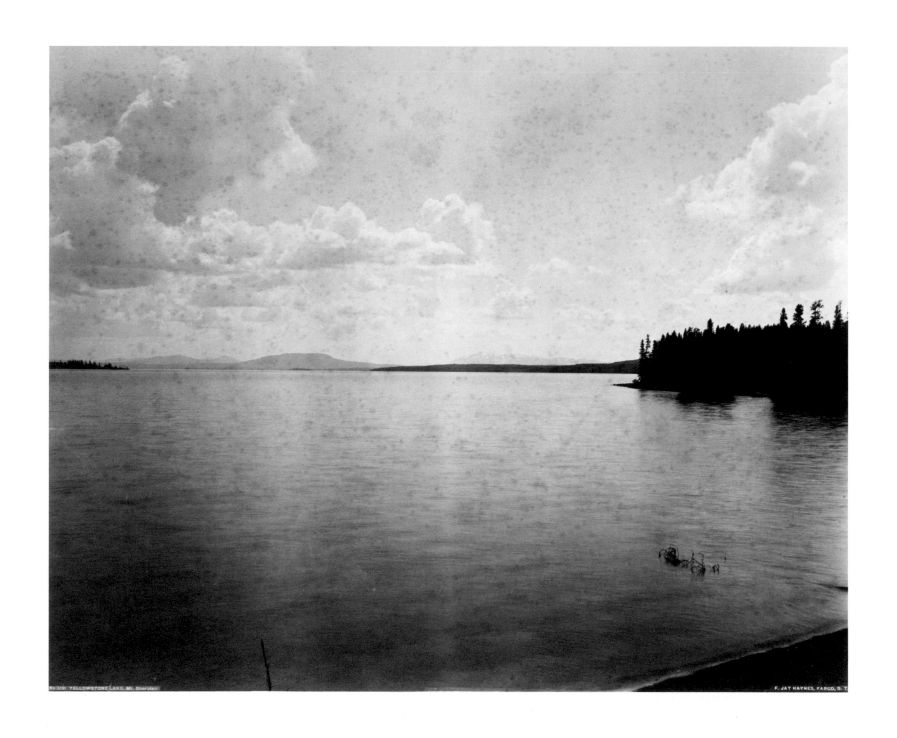

12 F. JAY HAYNES, YELLOWSTONE LAKE, MOUNT SHERIDAN, WYOMING, C. 1885

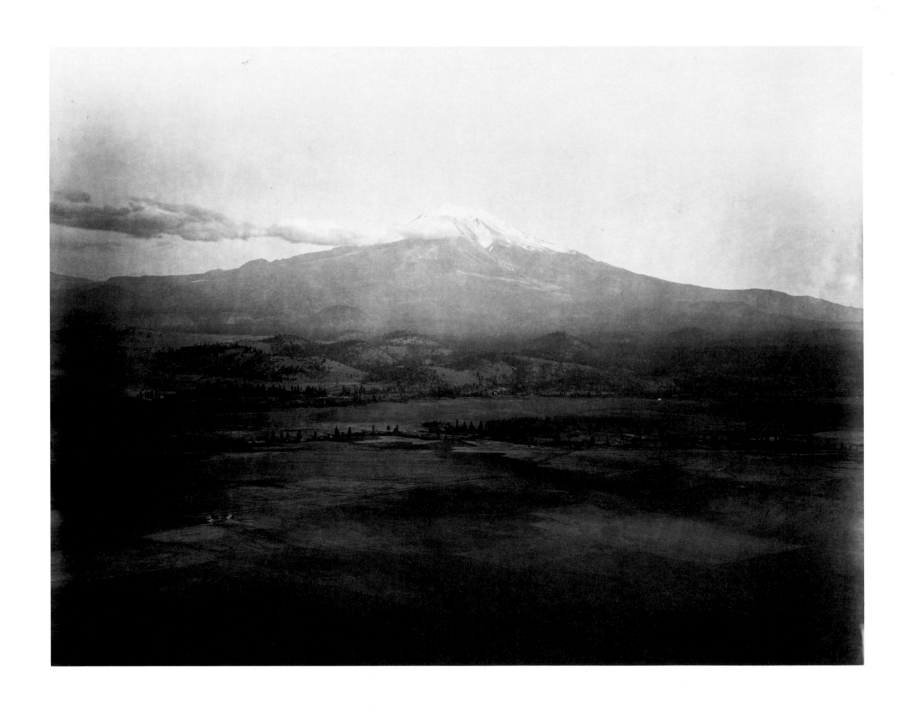

13 CARLETON WATKINS, MOUNT SHASTA FROM SHASTA VALLEY, CALIFORNIA, C. 1870

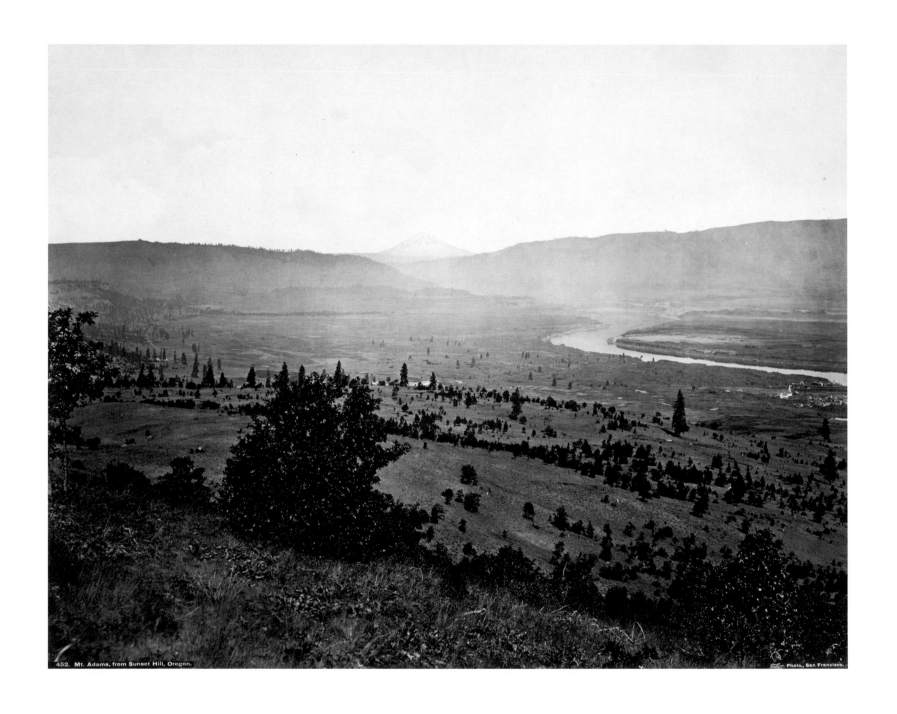

452. Mt. Adams, from Sunset Hill, Oregon.

Taber, Photo., San Francisco.

14 CARLETON WATKINS, MOUNT ADAMS FROM SUNSET HILL, DALLES CITY, OREGON, C. 1867

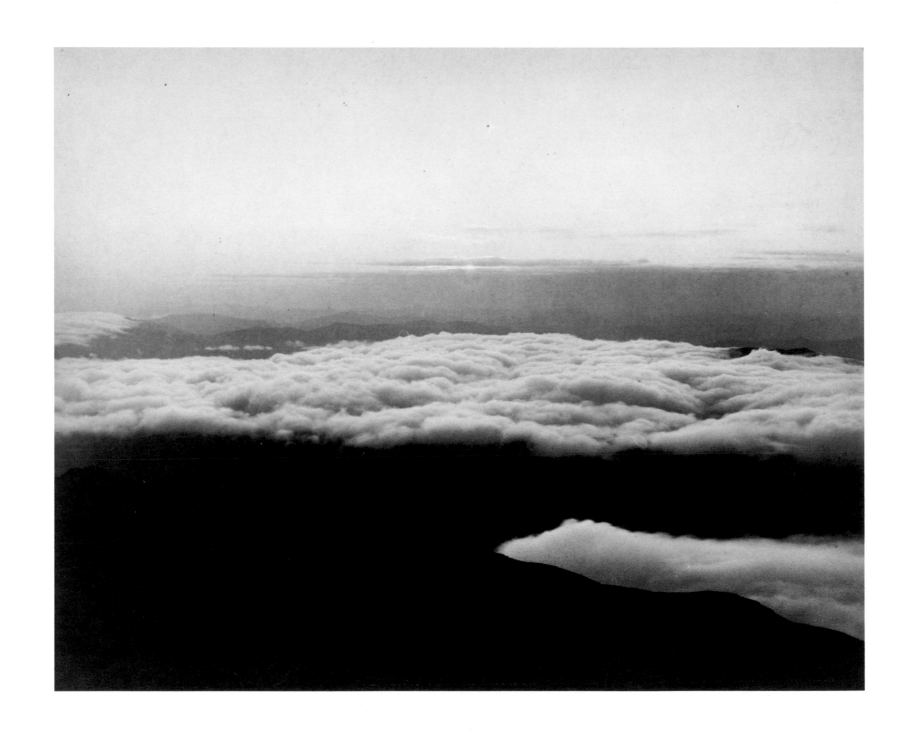

15 C. P. HIBBARD, SUNRISE ON MOUNT WASHINGTON, NEW HAMPSHIRE, C. 1890

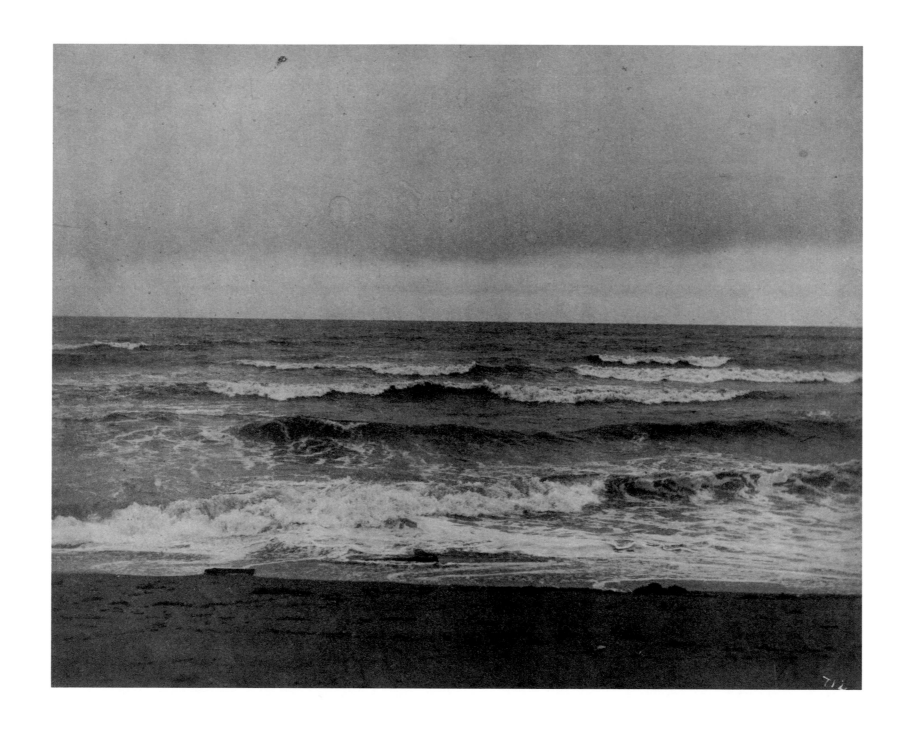

16 T. E. M. & G. F. WHITE, NEW BEDFORD, MASSACHUSETTS, C. 1900

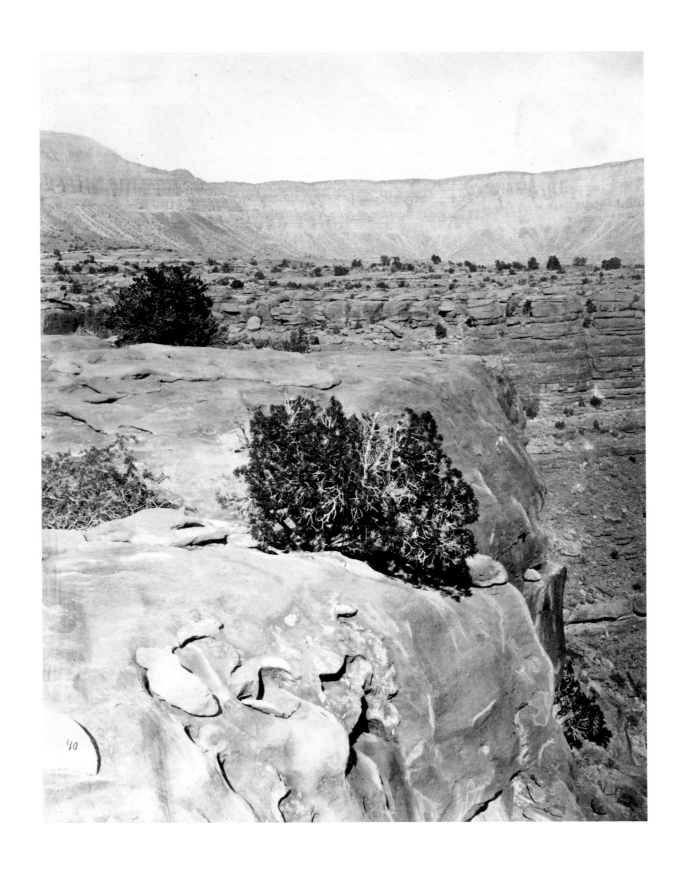

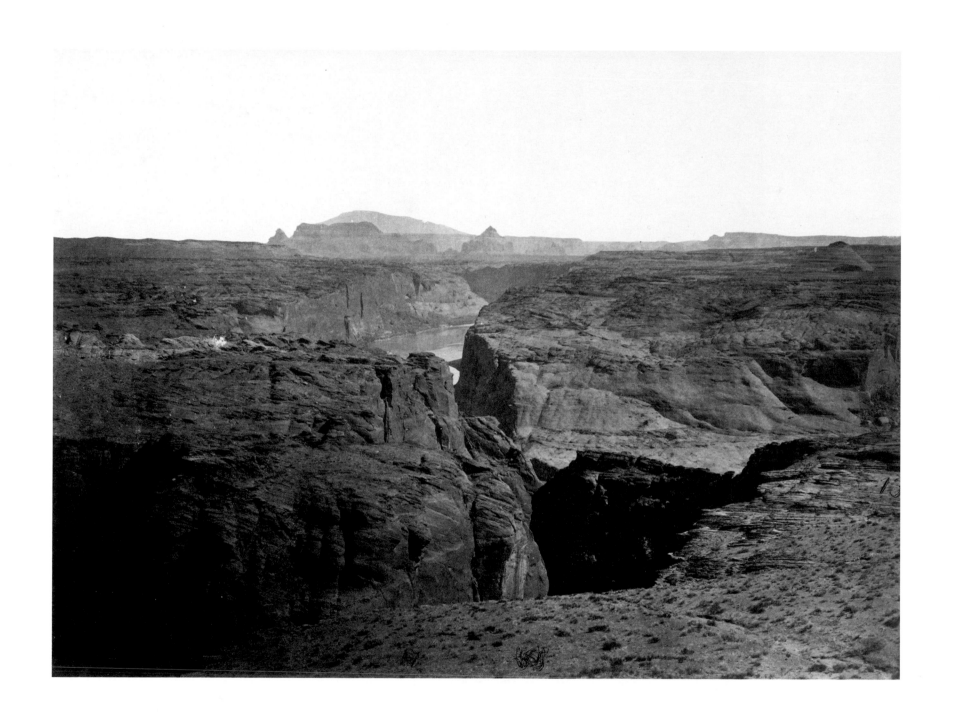

18 TIMOTHY O'SULLIVAN, CANON OF THE COLORADO RIVER, NEAR MOUTH OF THE SAN JUAN RIVER, UTAH, 1873

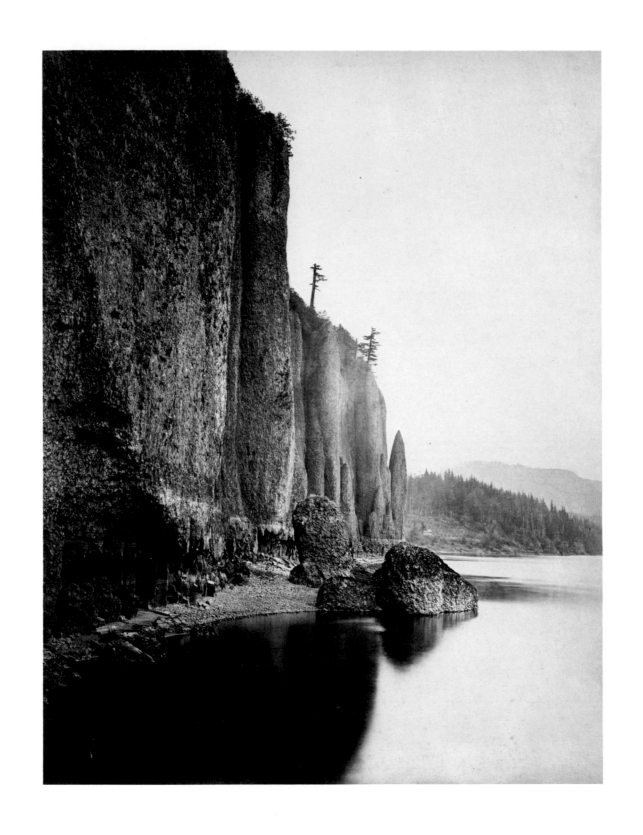

19 CARLETON WATKINS, CAPE HORN, COLUMBIA RIVER, IDAHO, 1867

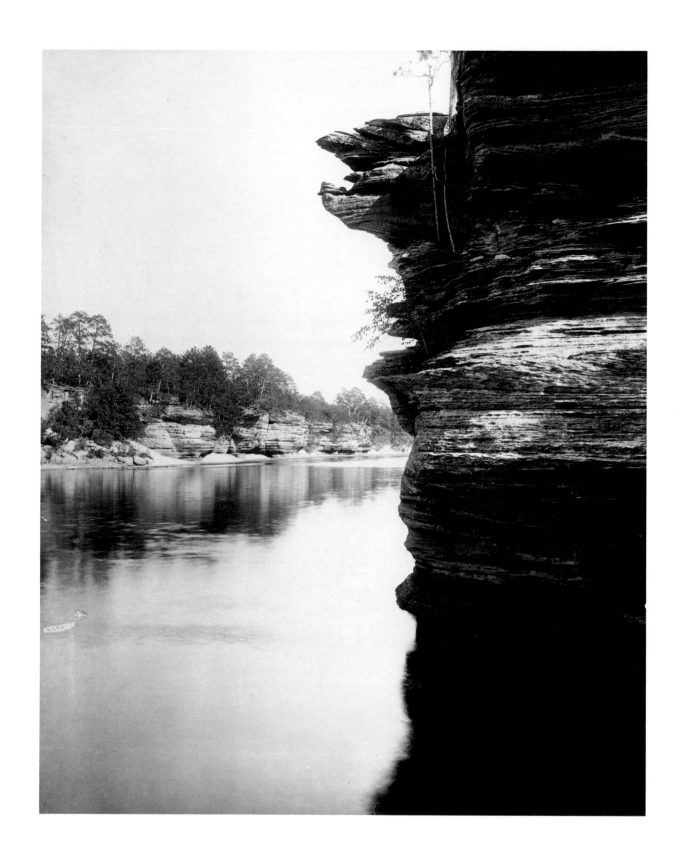

20 H. H. BENNETT, UNTITLED (WISCONSIN DELLS), C. 1880

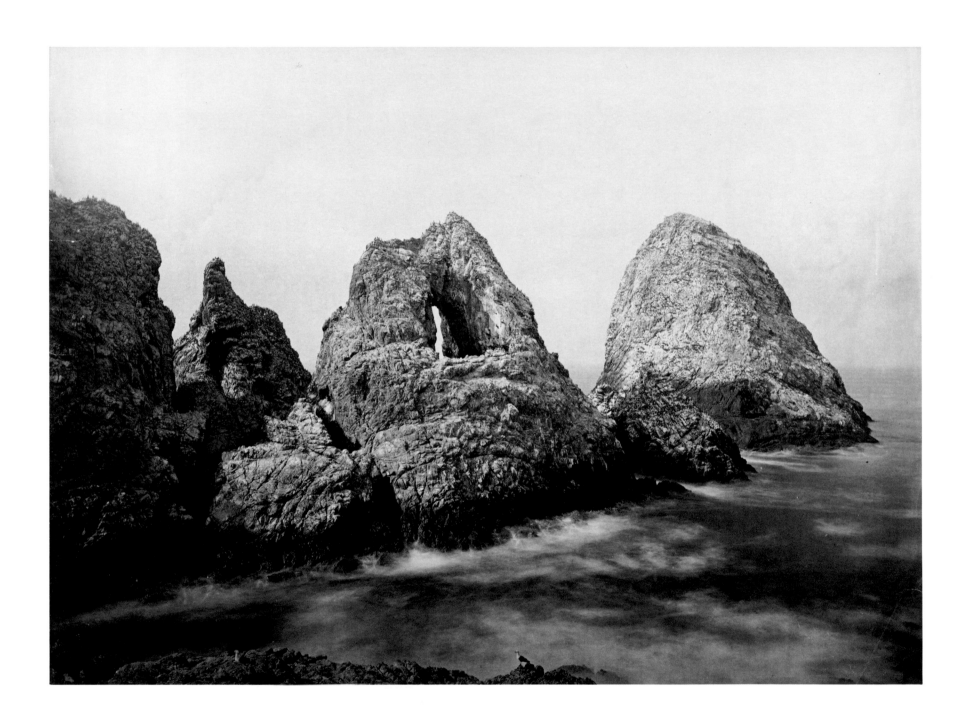

21 CARLETON WATKINS, SEAL ROCK, OREGON, C. 1870

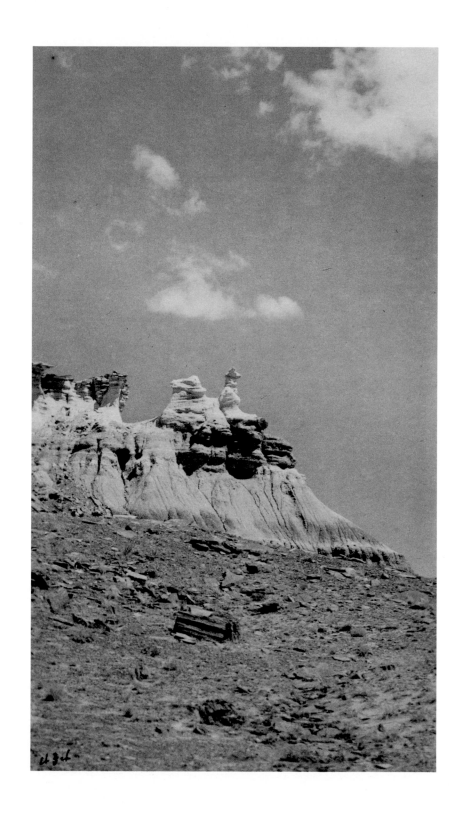

22 ADAM CLARK VROMAN, LOG IN BLUFF, ARIZONA, AUGUST 1902

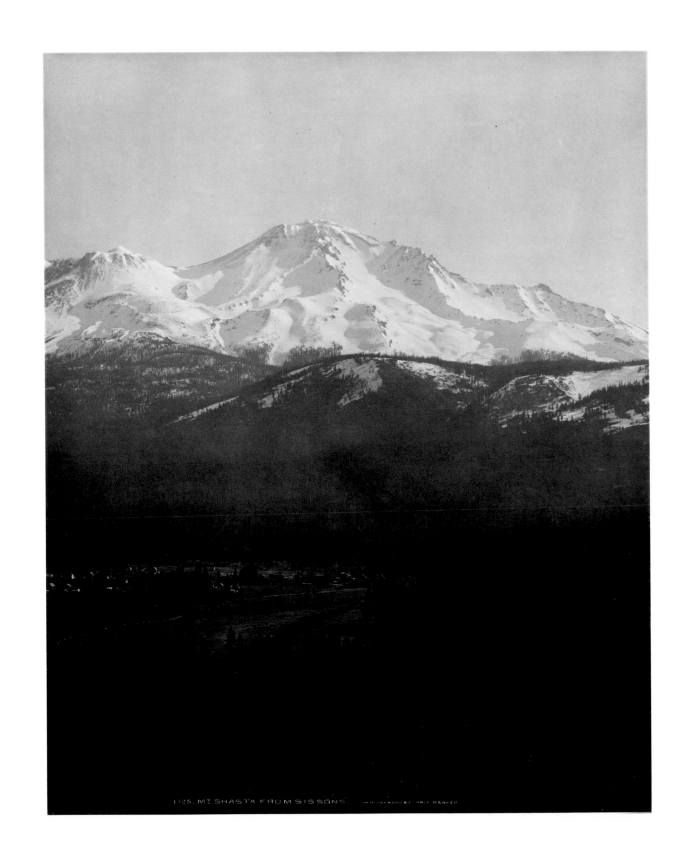

1025. MT SHASTA FROM SISSONS. WM. JACKSON PH. CO. DENVER.

23 WILLIAM HENRY JACKSON, MOUNT SHASTA FROM SISSONS, CALIFORNIA, C. 1870

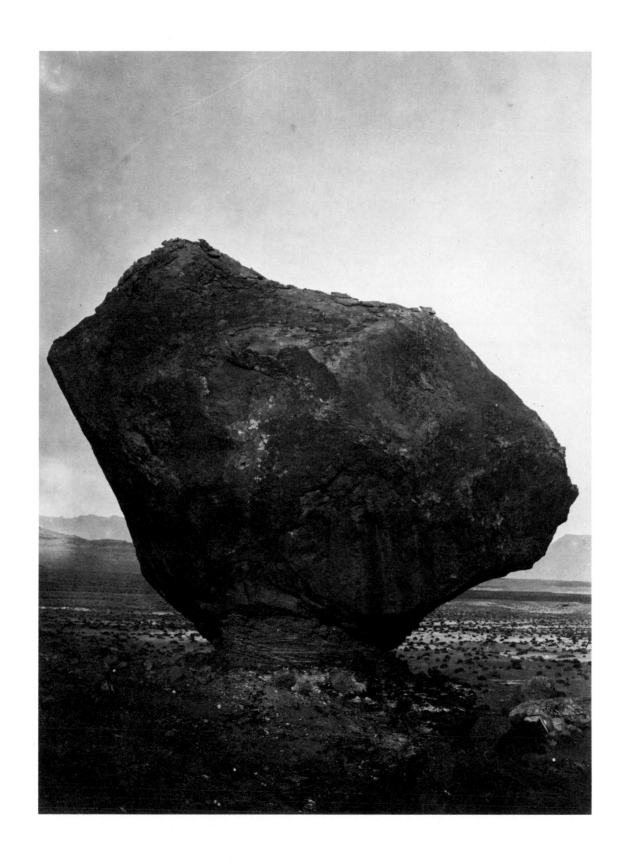

24 WILLIAM BELL, PERCHED ROCK, ROCKER CREEK, ARIZONA, 1872

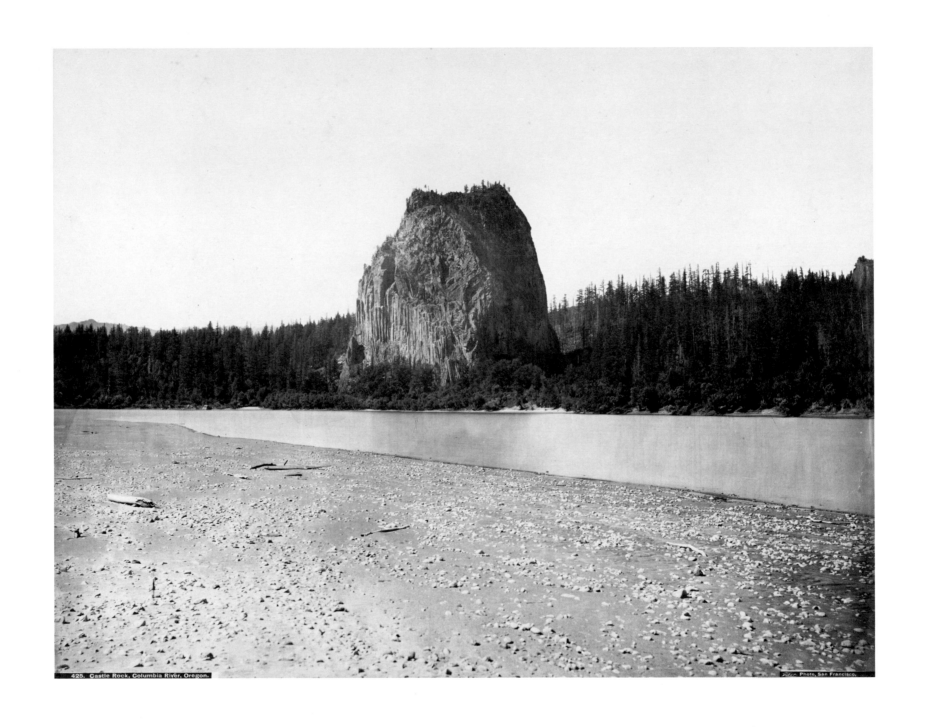

425. Castle Rock, Columbia River, Oregon.

Photo, San Francisco.

CARLETON WATKINS, CASTLE ROCK, COLUMBIA RIVER, OREGON, C. 1867

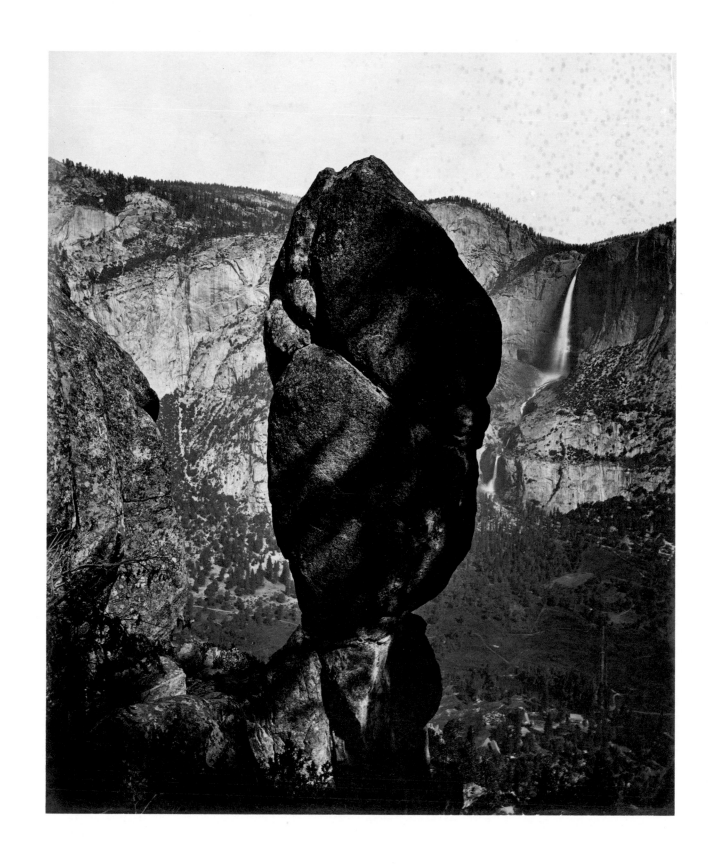

26 CARLETON WATKINS, AGASSIZ ROCK, CALIFORNIA, C. 1870

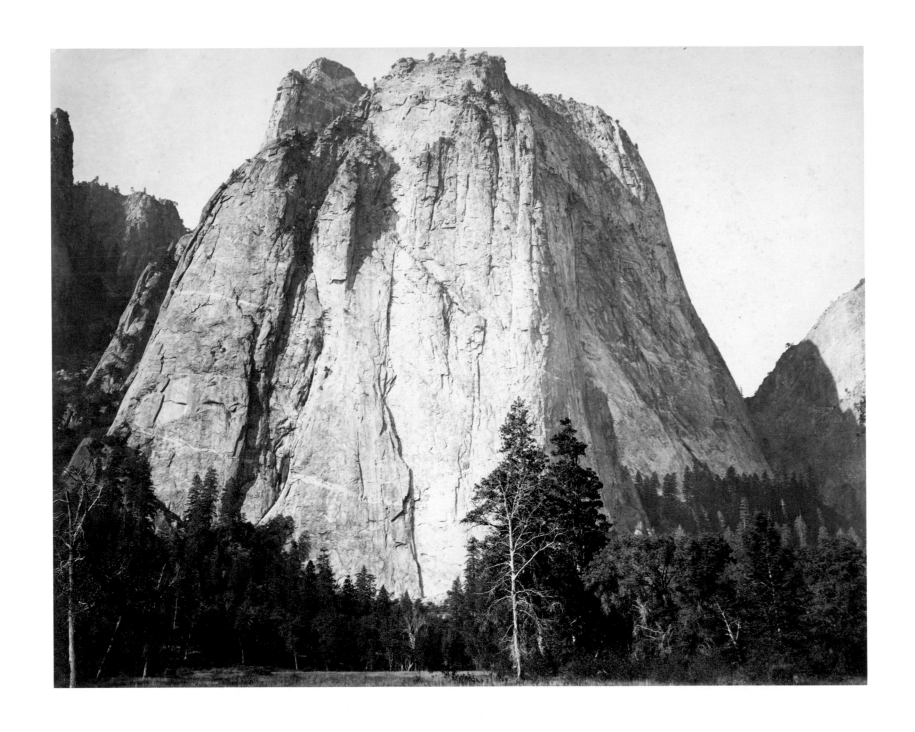

CARLETON WATKINS, CATHEDRAL ROCKS, YOSEMITE, CALIFORNIA, 1866

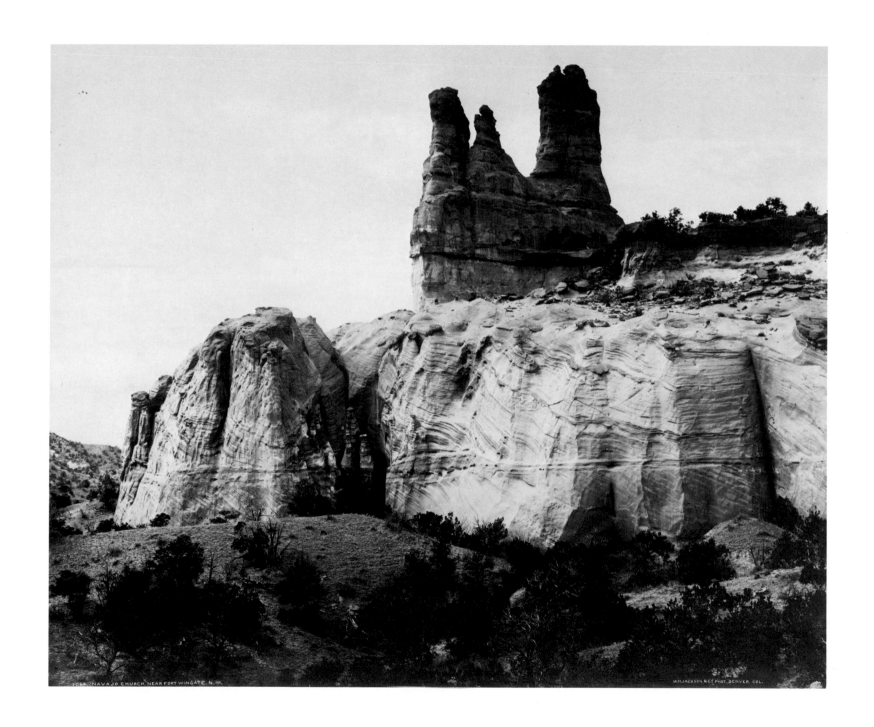

28 WILLIAM HENRY JACKSON, NAVAJO CHURCH NEAR FORT WINGATE, NEW MEXICO, C. 1880

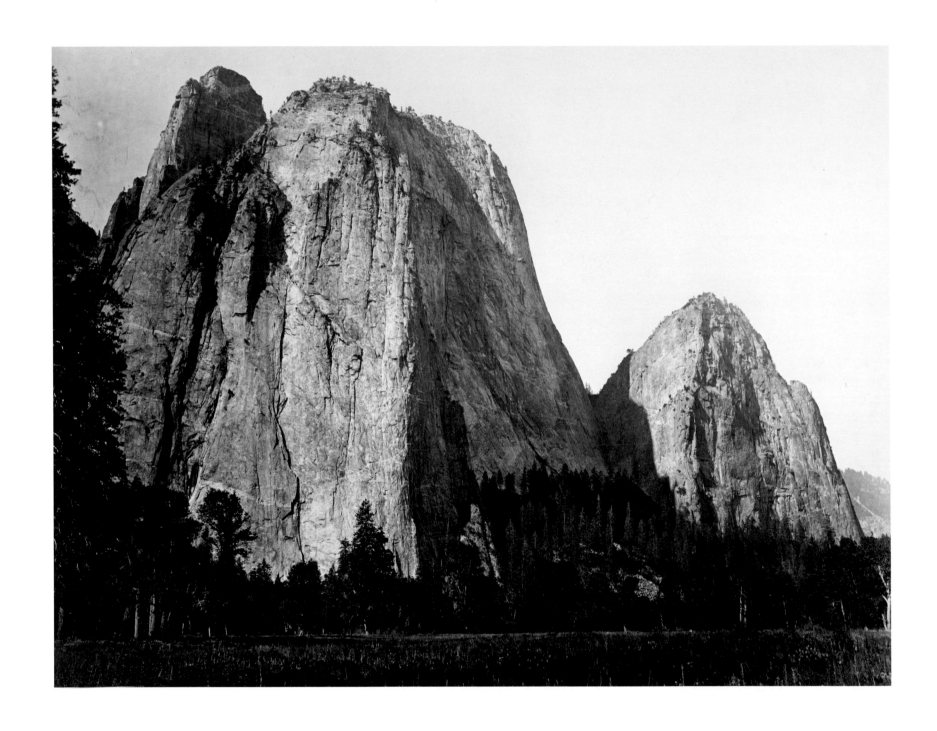

29 CARLETON WATKINS, CATHEDRAL ROCKS, YOSEMITE, CALIFORNIA, 1866

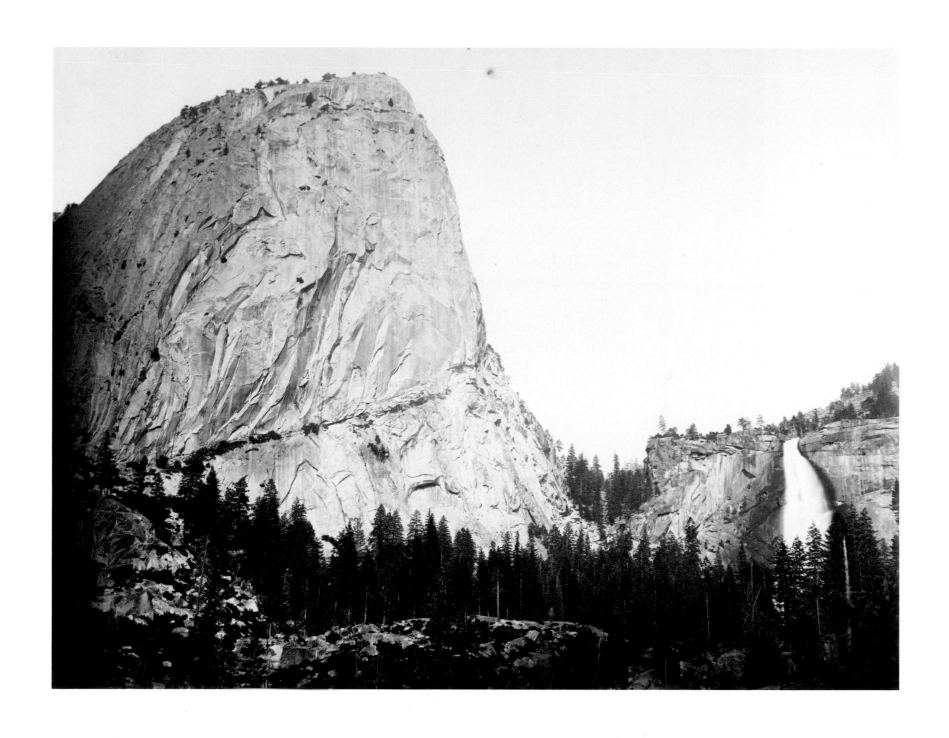

30 CARLETON WATKINS, NEVADA FALL AND BUTTE, CALIFORNIA, C. 1870

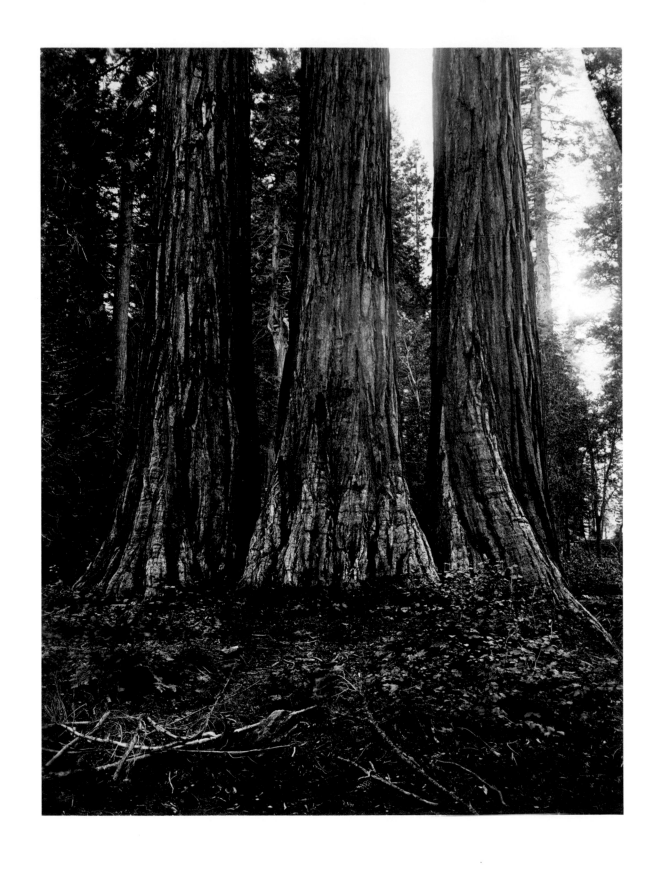

31 THOMAS HOUSEWORTH AND CO., THE THREE GRACES, CALIFORNIA, C. 1875

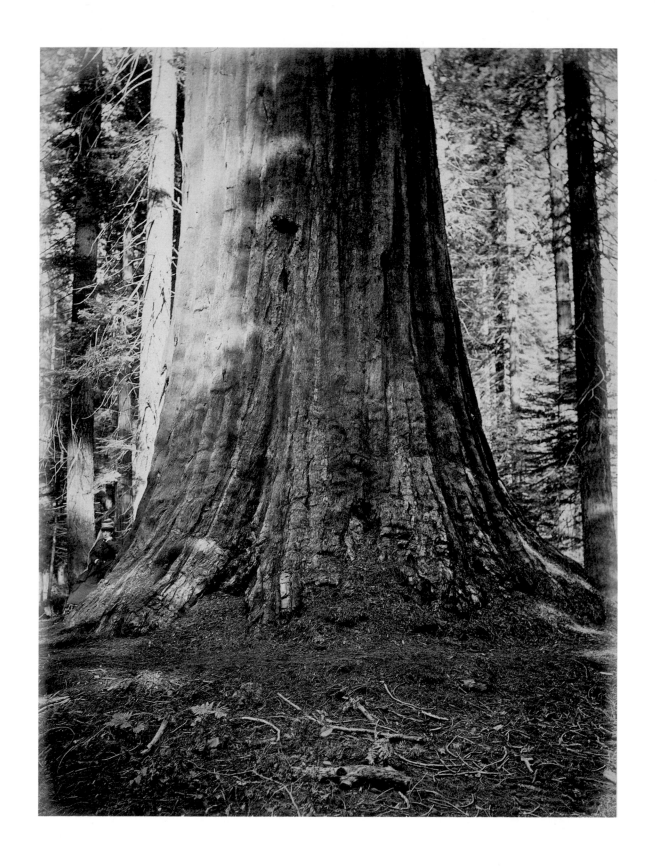

32 CARLETON WATKINS, SEQUOIA GIGANTEA DECAISNE, C. 1866

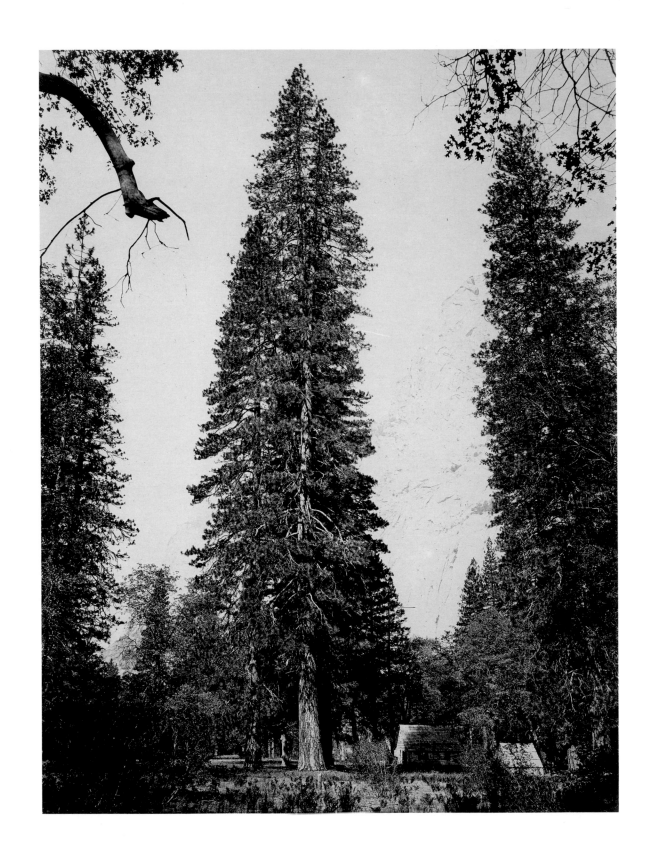

33 CARLETON WATKINS, PONDEROSA, YOSEMITE, CALIFORNIA, C. 1870

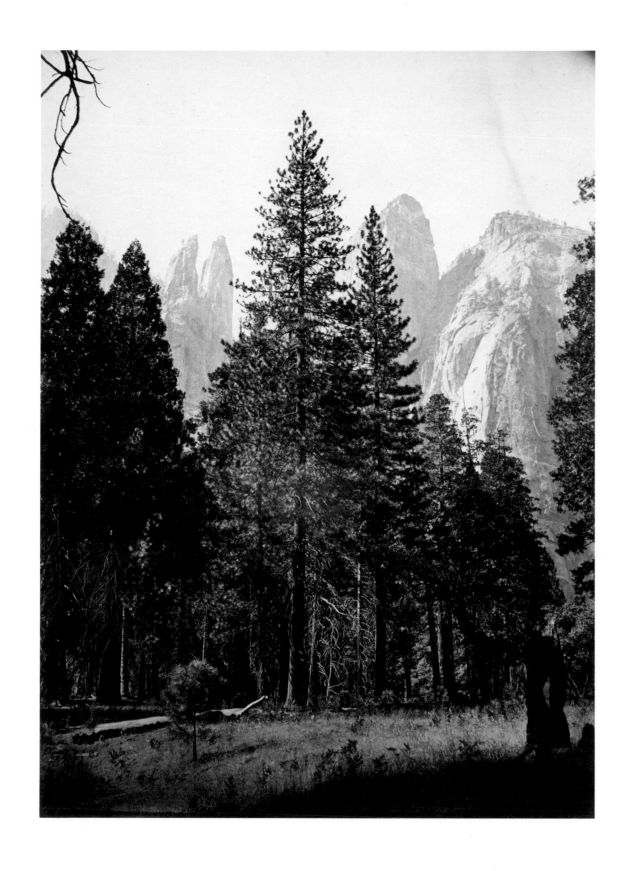

34 CARLETON WATKINS, CATHEDRAL SPIRES, CALIFORNIA, C. 1866

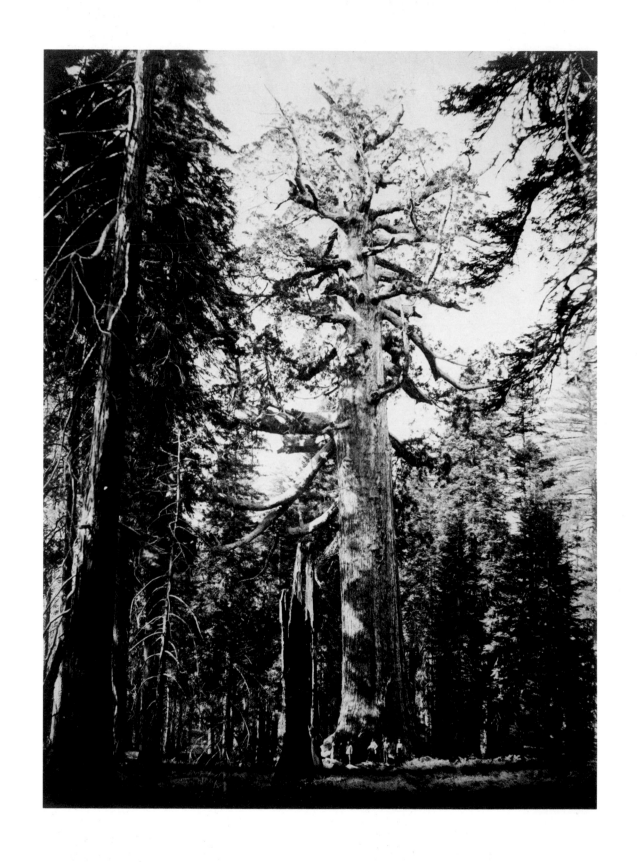

35 CARLETON WATKINS, CALIFORNIA SEQUOIA GIGANTA 'GRIZZLY GIANT,' MARIPOSA GROVE, 1866

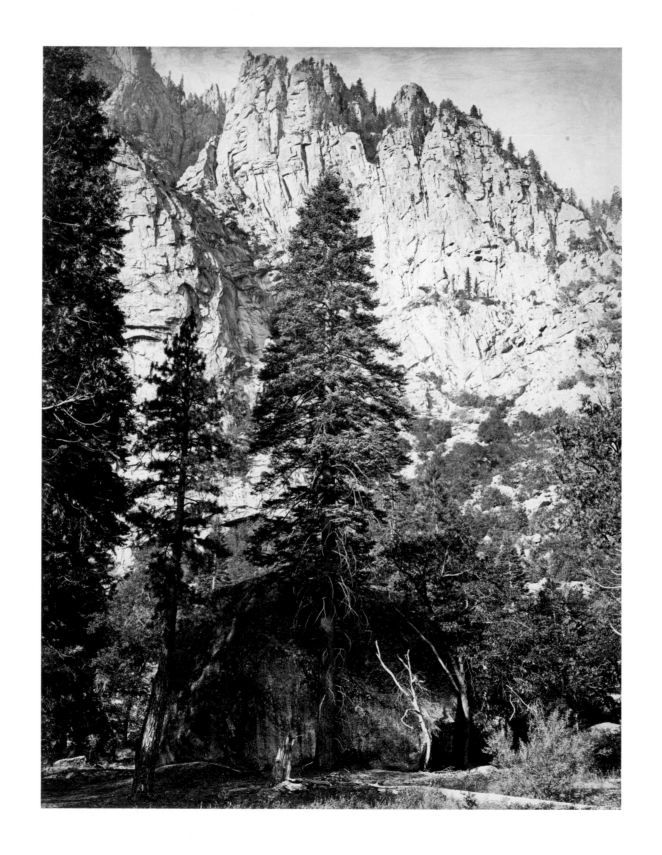

36 CARLETON WATKINS, AMANULES, CALIFORNIA, C. 1870

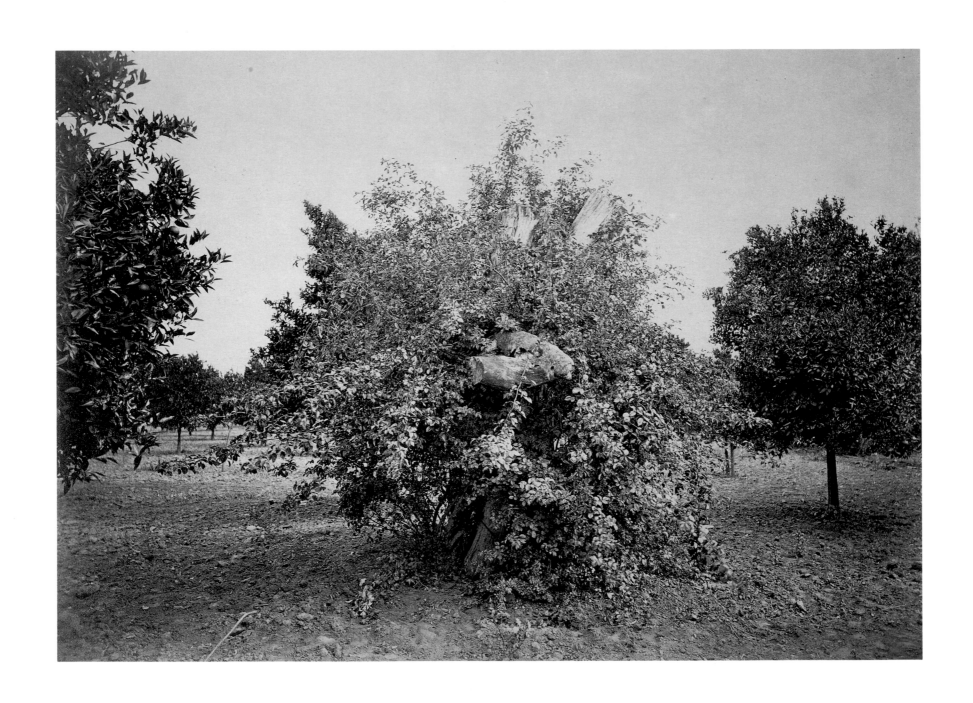

37 CARLETON WATKINS, ROSETREE AND ORANGE GROVE, RESIDENCE OF GOVERNOR STONEMAN, CALIFORNIA, C. 1880

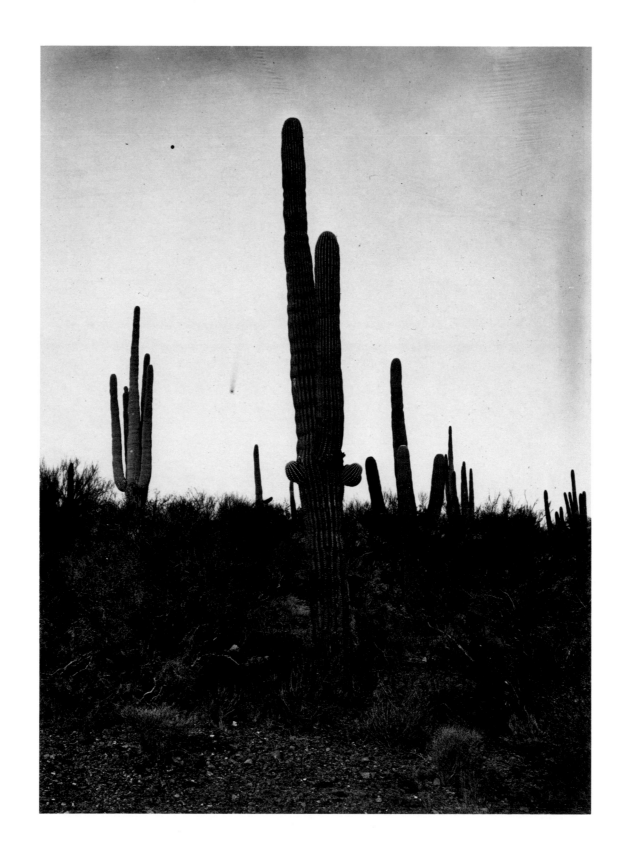

38 TIMOTHY O'SULLIVAN, CEREUS GIGANTEUS, ARIZONA, 1871

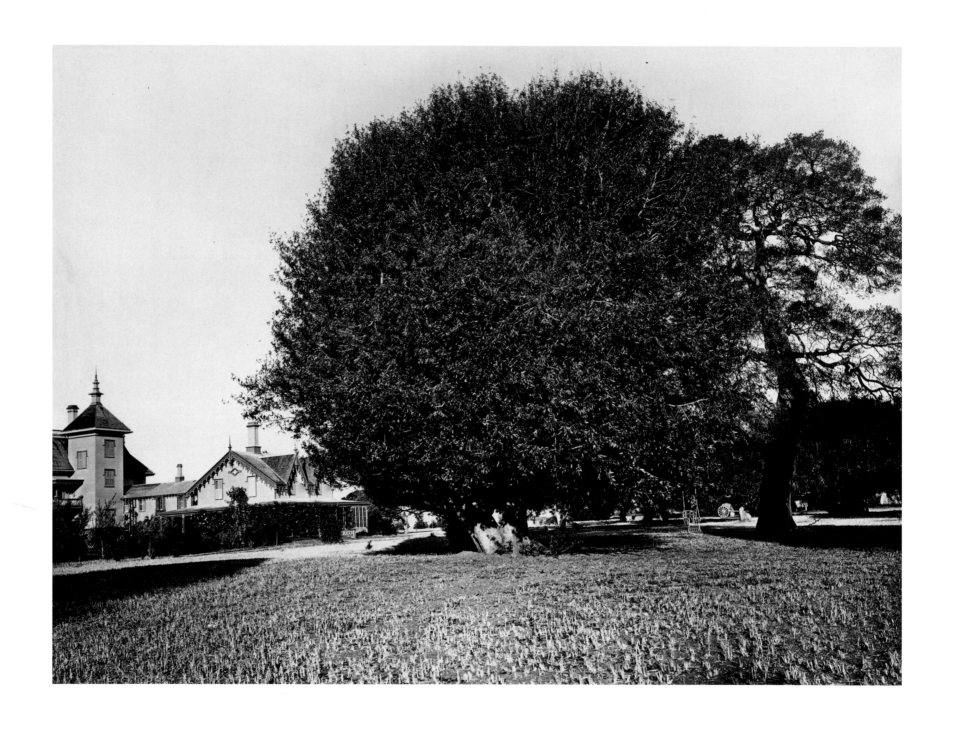

39 CARLETON WATKINS, UNTITLED, C. 1870

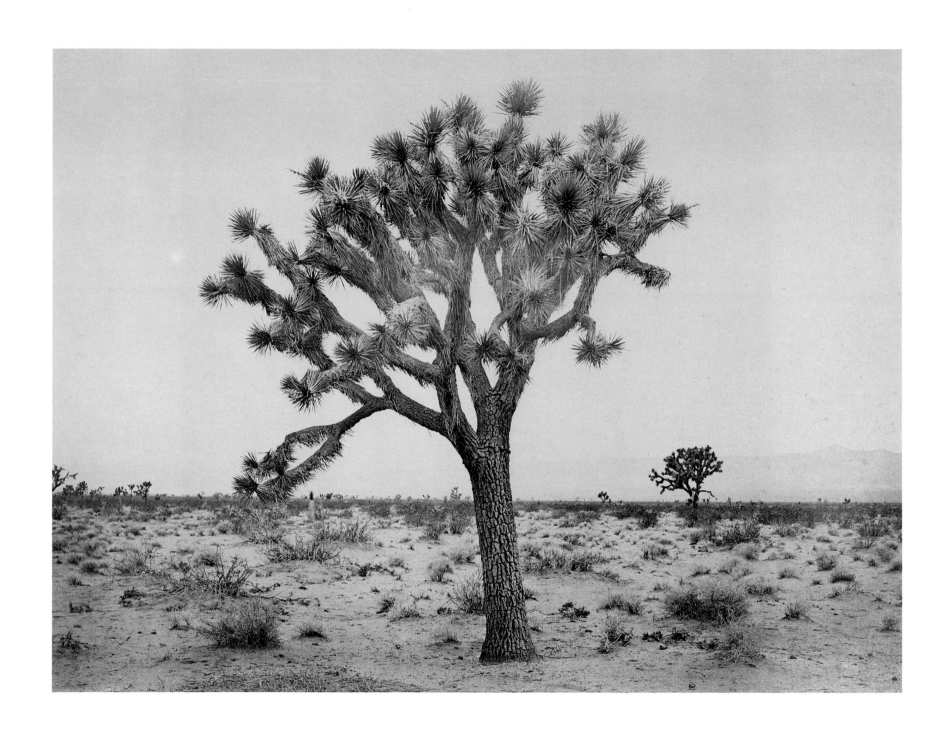

40 CARLETON WATKINS, YUCCA DRACONIS, MOJAVE DESERT, CALIFORNIA, C. 1880

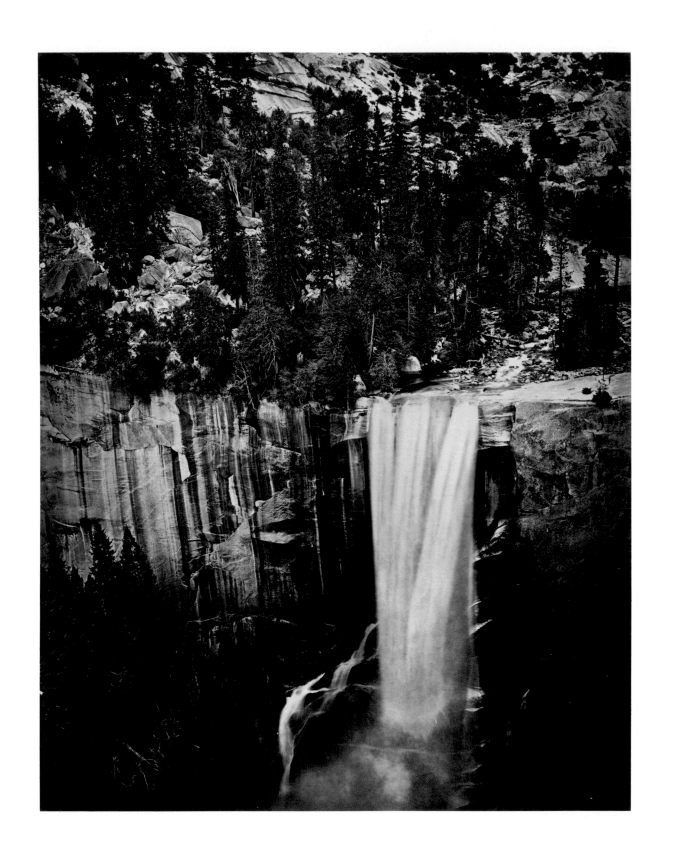

41 EADWEARD MUYBRIDGE, PI-WI-ACK (SHOWER OF STARS), VERNAL FALLS, CALIFORNIA, 1872

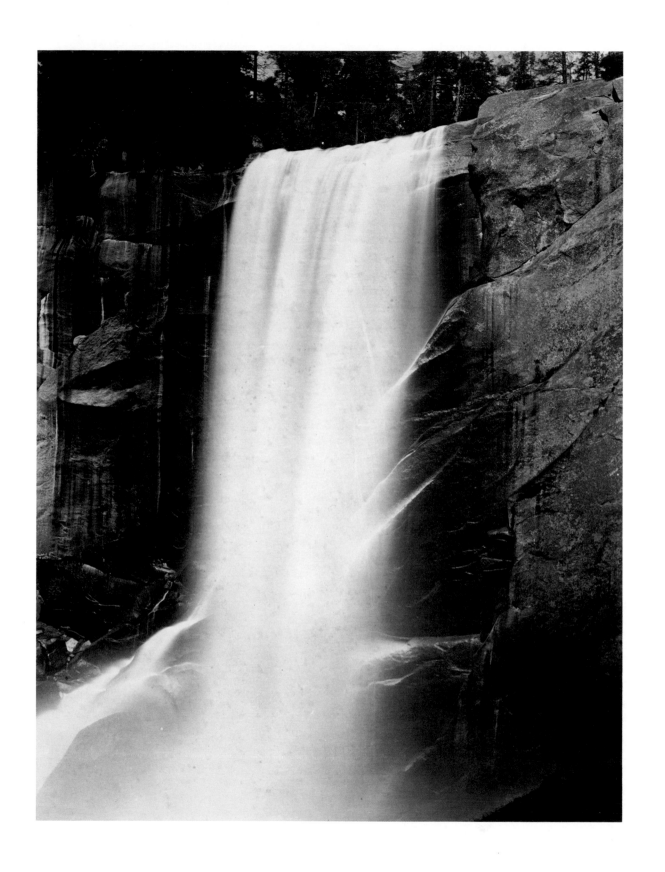

EADWEARD MUYBRIDGE, VERNAL FALLS, YOSEMITE VALLEY, CALIFORNIA, C. 1865

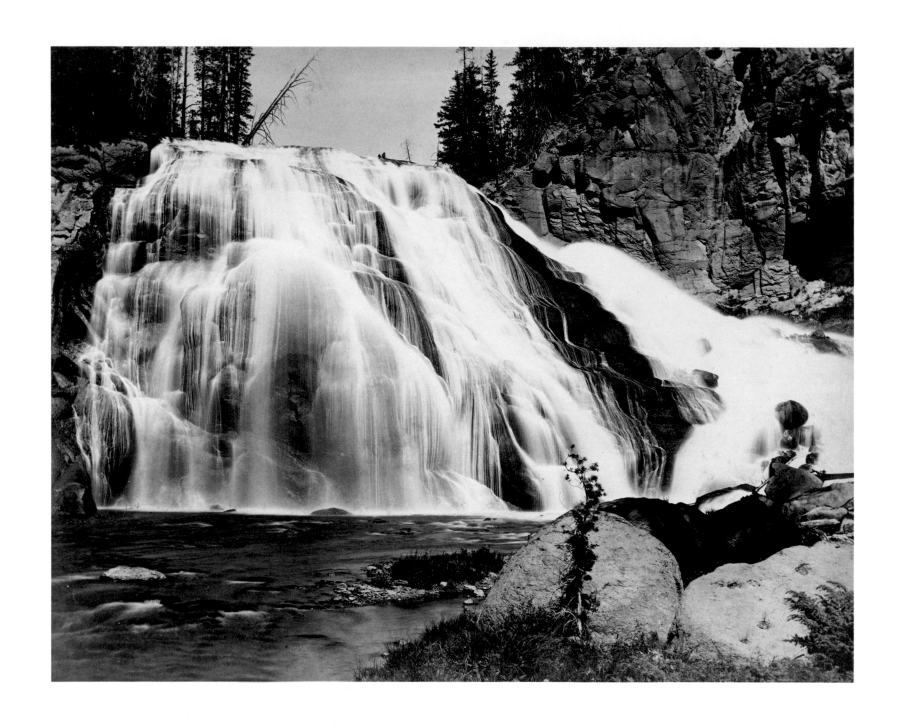

43 F. JAY HAYNES, GIBBON FALLS, YELLOWSTONE, WYOMING, C. 1885

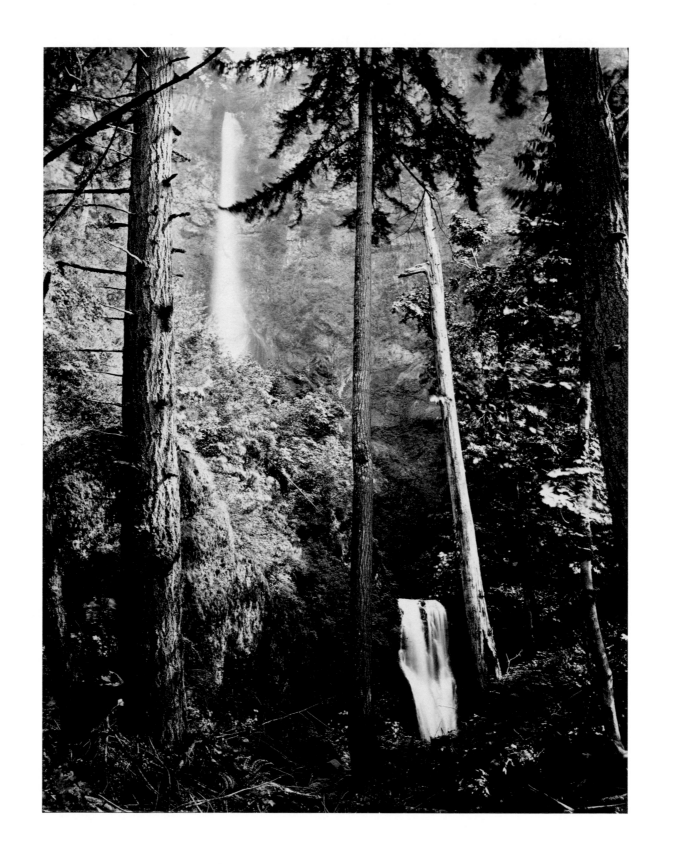

44 CARLETON WATKINS, MULTNOMAH FALLS, COLUMBIA RIVER, OREGON, C. 1867

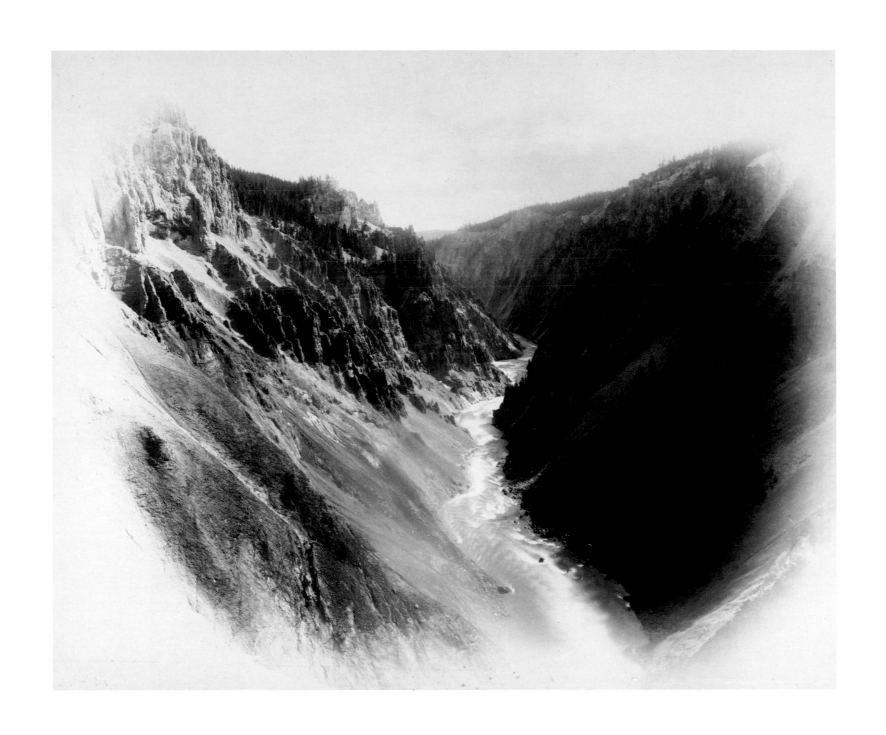

45 F. JAY HAYNES, CANYON OF THE YELLOWSTONE, WYOMING, C. 1885

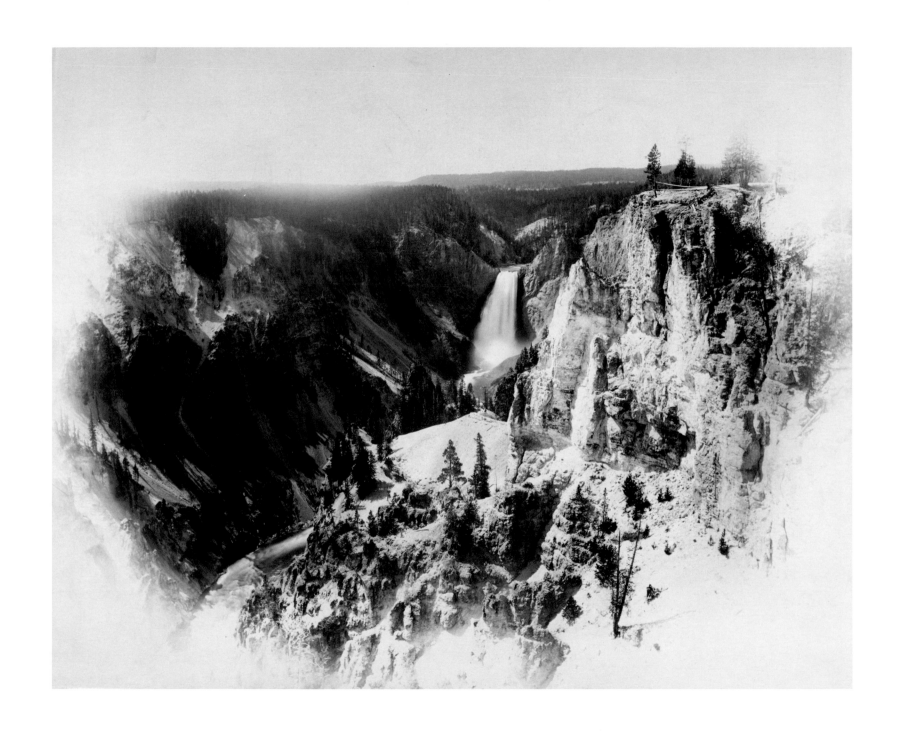

46 F. JAY HAYNES, YELLOWSTONE FALLS, WYOMING, C. 1885

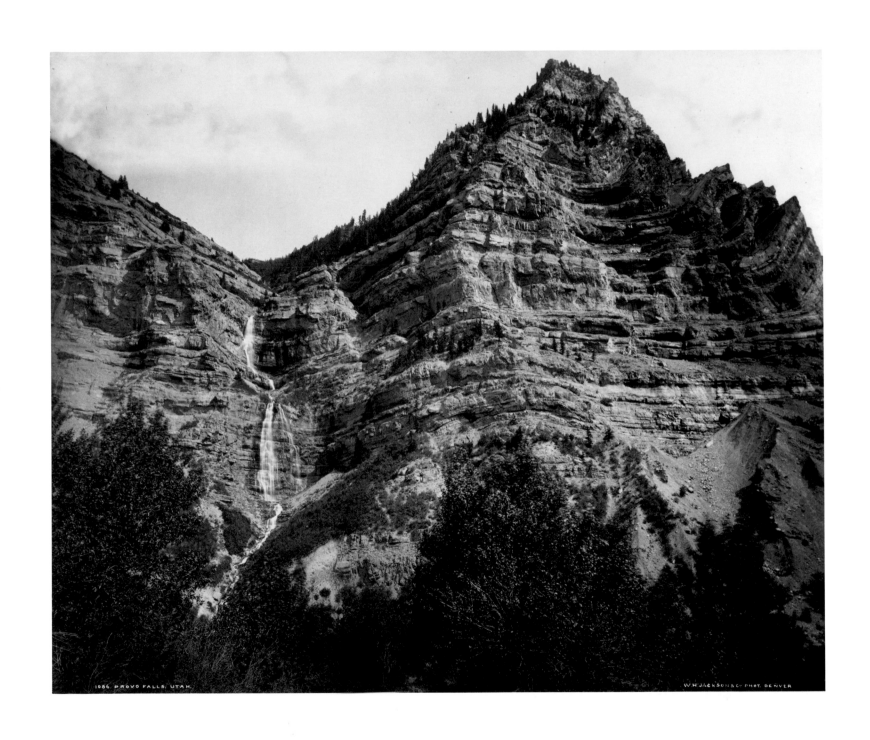

47 WILLIAM HENRY JACKSON, PROVO FALLS, UTAH, C. 1875

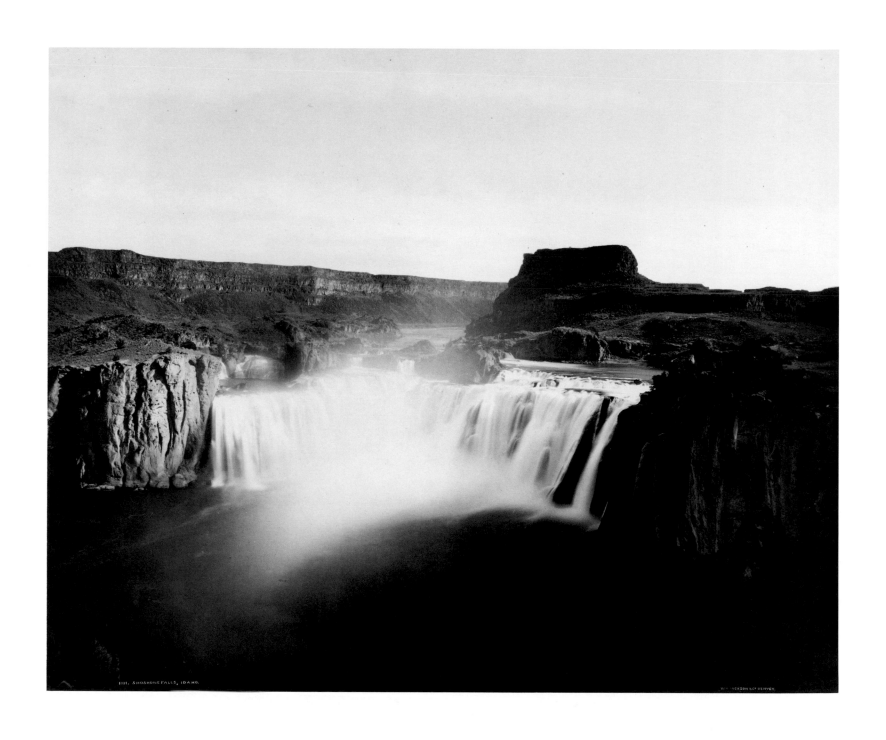

48 WILLIAM HENRY JACKSON, SHOSONE FALLS, IDAHO, C. 1868

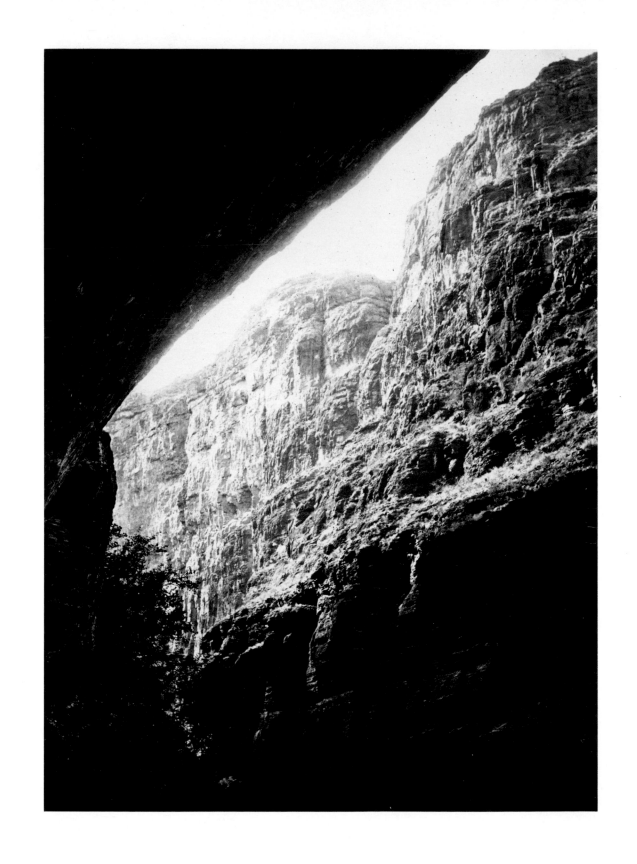

49 WILLIAM BELL, CANON OF KENAB WASH, COLORADO RIVER, ARIZONA, 1872

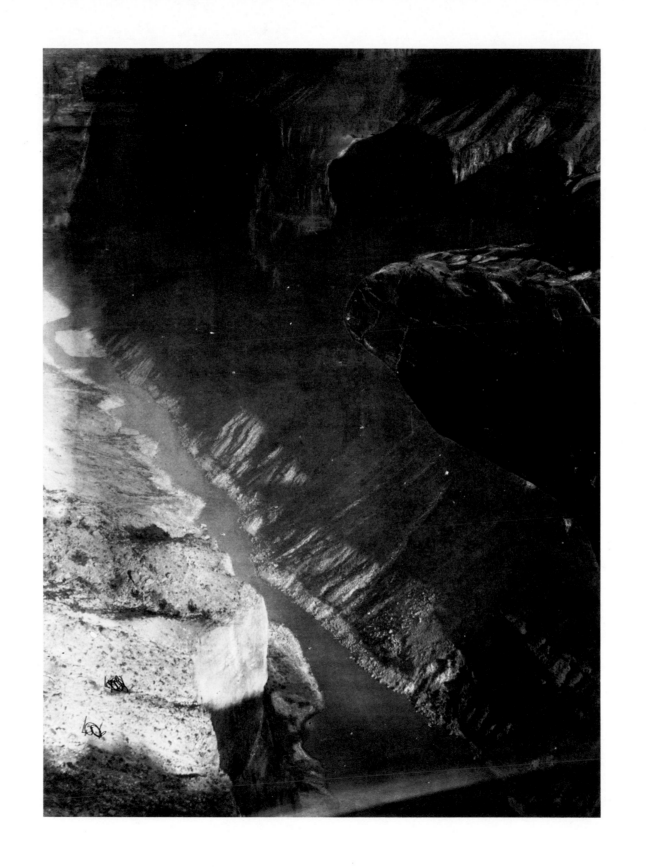

WILLIAM BELL, LOOKING SOUTH INTO THE GRAND CANON, COLORADO RIVER, ARIZONA

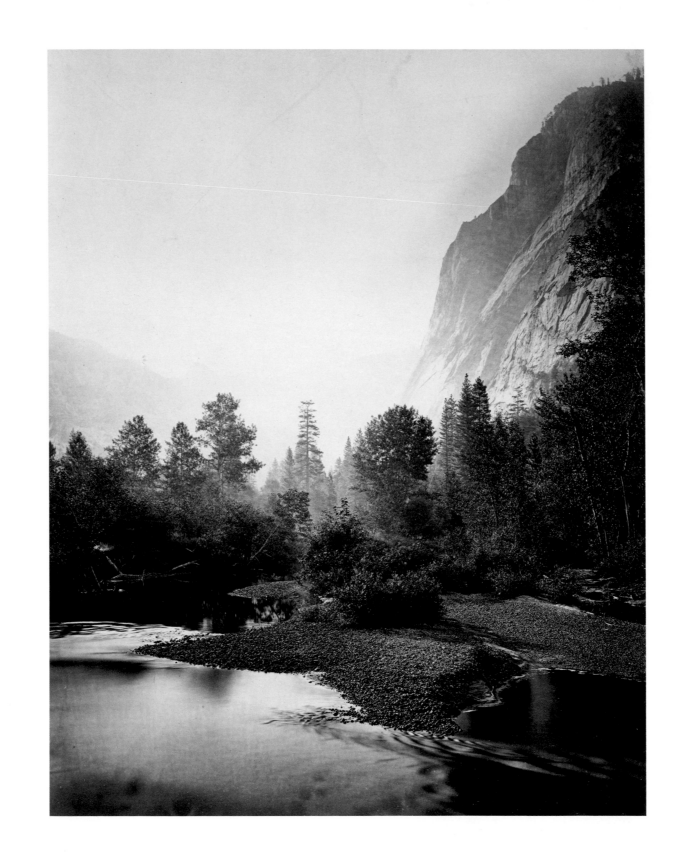

51 CARLETON WATKINS, MOUNT STARR KING, YOSEMITE, CALIFORNIA, 1866

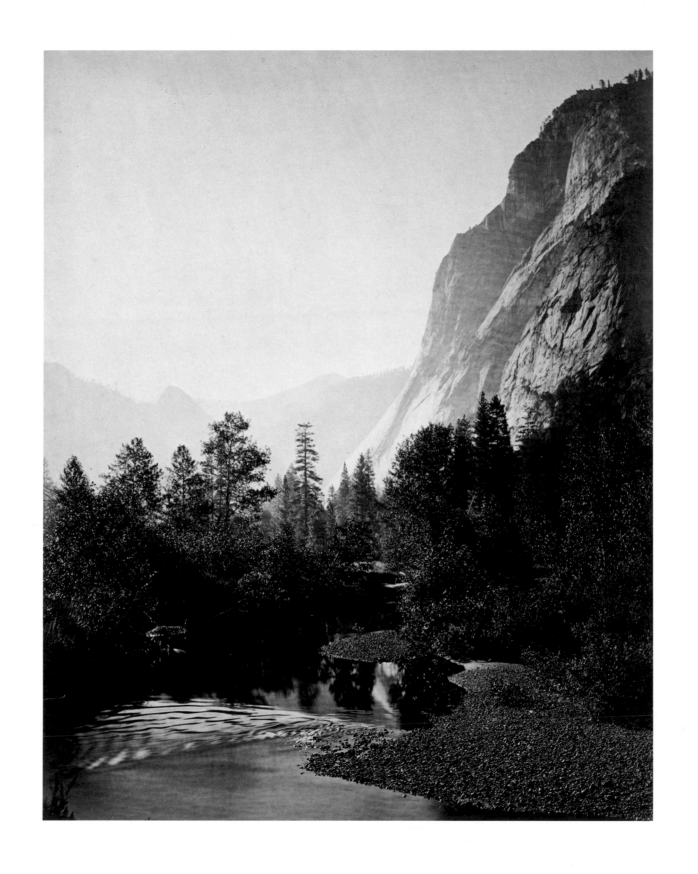

52 CARLETON WATKINS, MOUNT STARR KING, YOSEMITE, CALIFORNIA, 1866

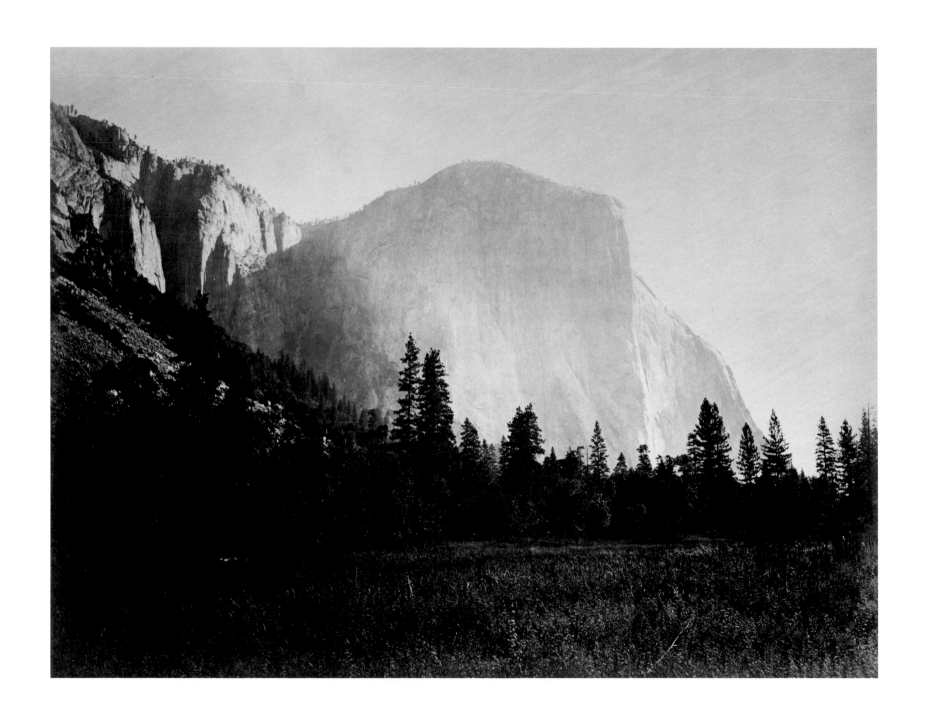

53 CARLETON WATKINS, EL CAPITAN AT THE FOOT OF THE MARIPOSA TRAIL, YOSEMITE VALLEY, CALIFORNIA, 1866

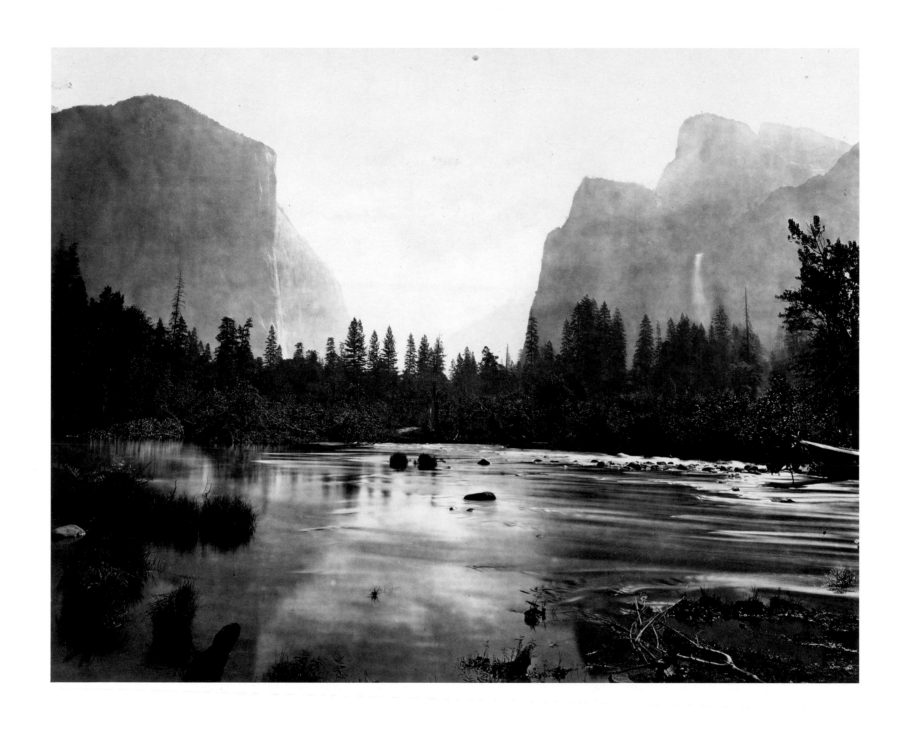

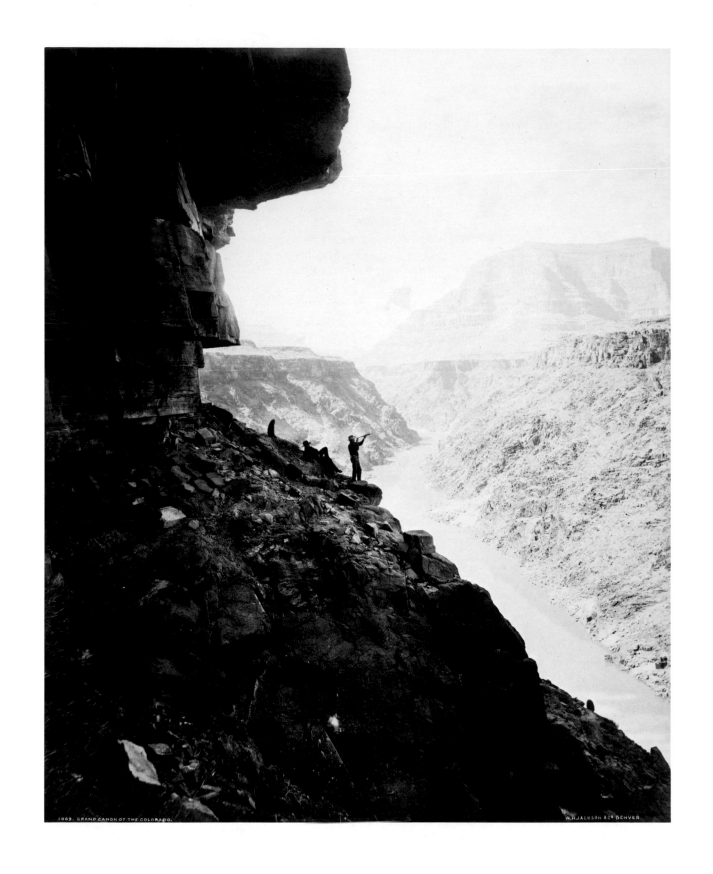

55 WILLIAM HENRY JACKSON, GRAND CANYON OF THE COLORADO, AFTER 1880

MAN AND NATURE

INDIANS

MAN AND SPACE

TRAINS

GROWTH

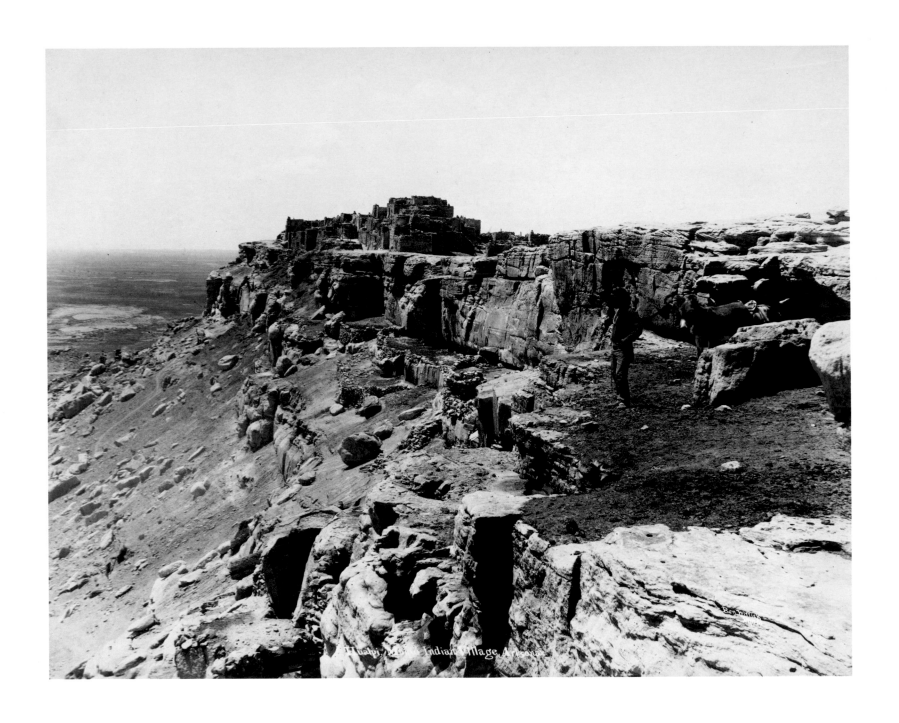

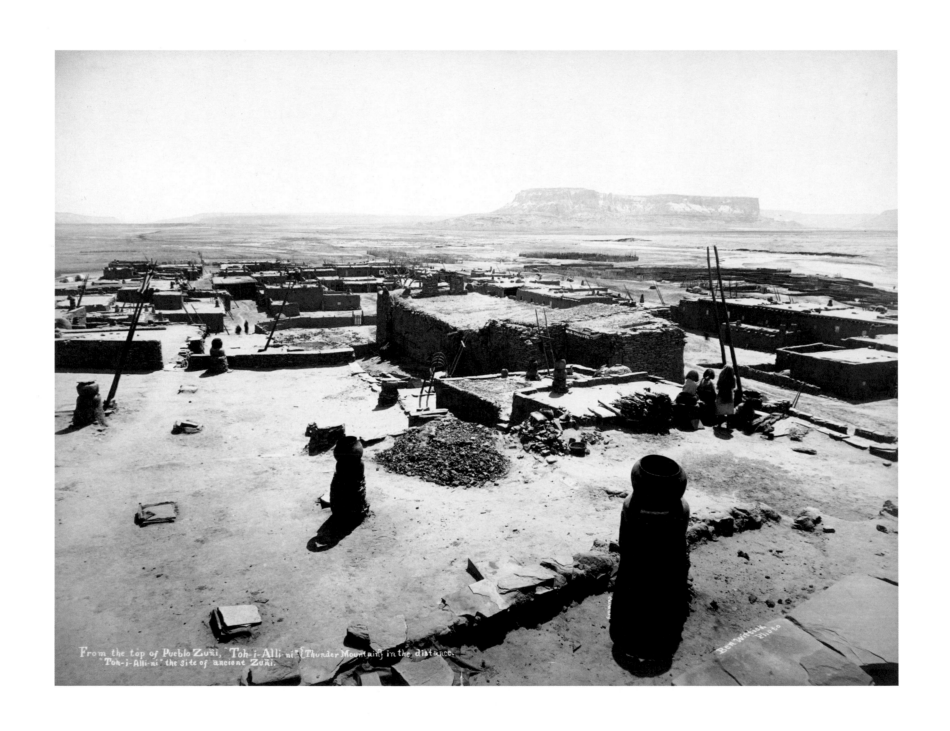

From the top of Pueblo Zuñi, "Toh-i-Alli-ni" (Thunder Mountain) in the distance.
"Toh-i-Alli-ni" the Site of ancient Zuñi.

57 BEN WITTICK, FROM THE TOP OF ZUNI, TOH-I-ALLI-NI, ARIZONA, C. 1870S

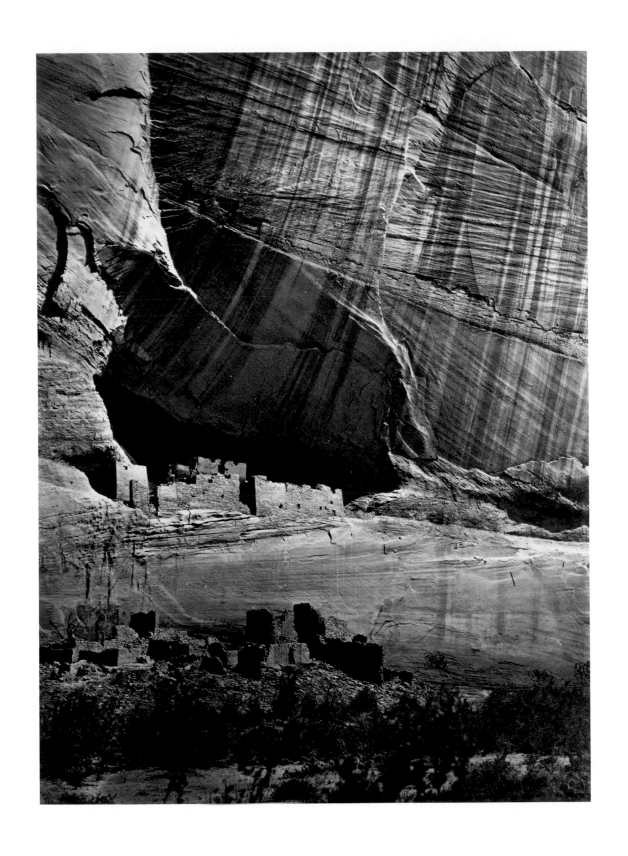

58 TIMOTHY O'SULLIVAN, ANCIENT RUINS, CANON DE CHELLE, NEW MEXICO, 1873

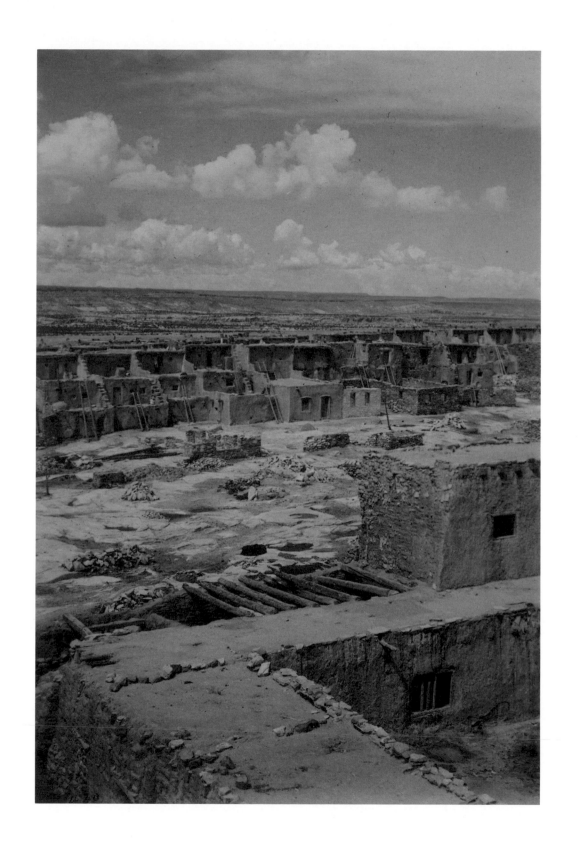

59 ADAM CLARK VROMAN, ACOMA FROM CHURCH TOWER, NEW MEXICO, AUGUST 1902

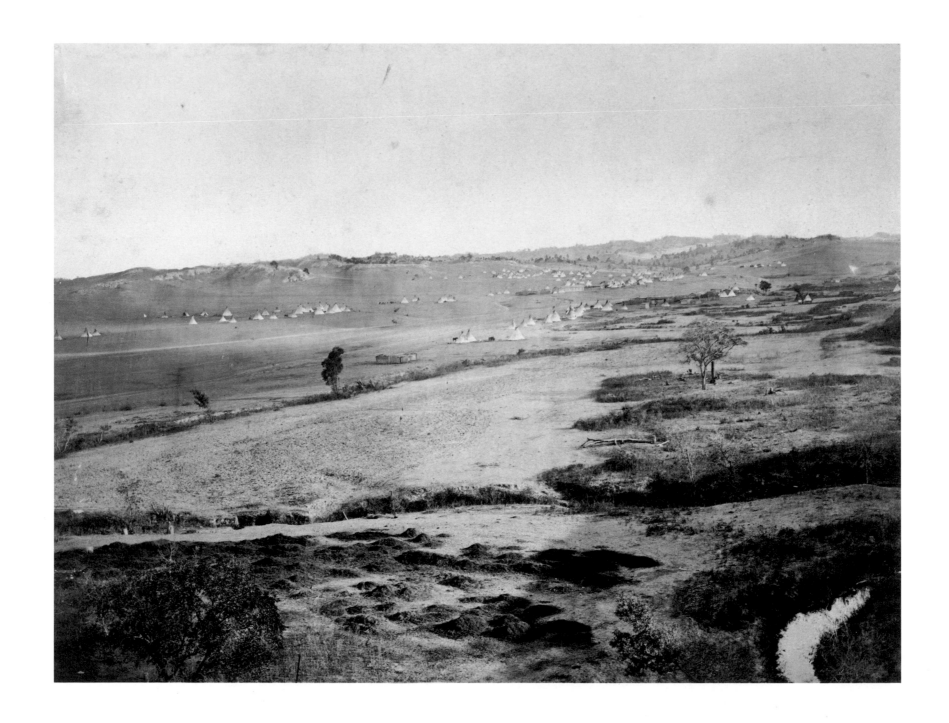

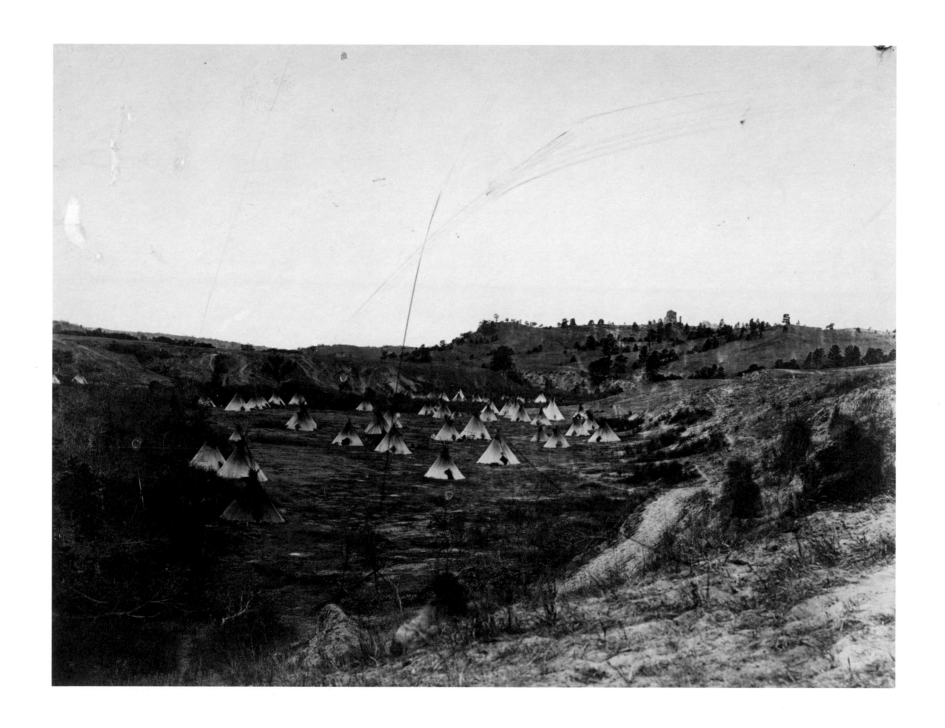

61 ———— HOWARD, SIOUX VILLAGE ON WHITE RIVER, C. 1868

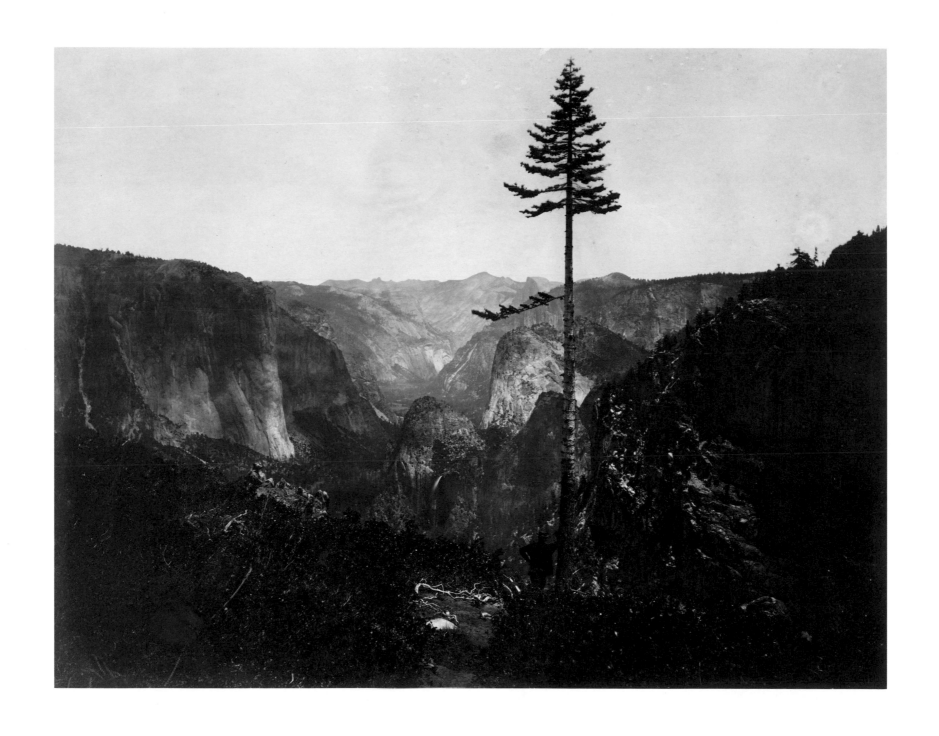

62 C. L. WEED, THE VALLEY, FROM THE MARIPOSA TRAIL, CALIFORNIA, C. 1865

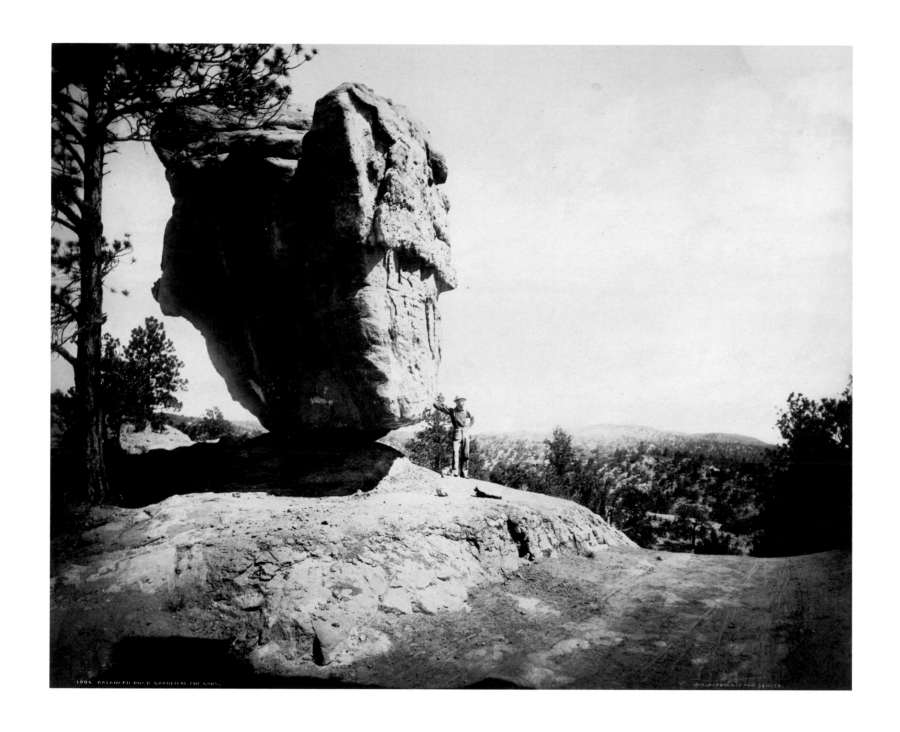

63 WILLIAM HENRY JACKSON, BALANCED ROCK, GARDEN OF THE GODS, COLORADO, C. 1880

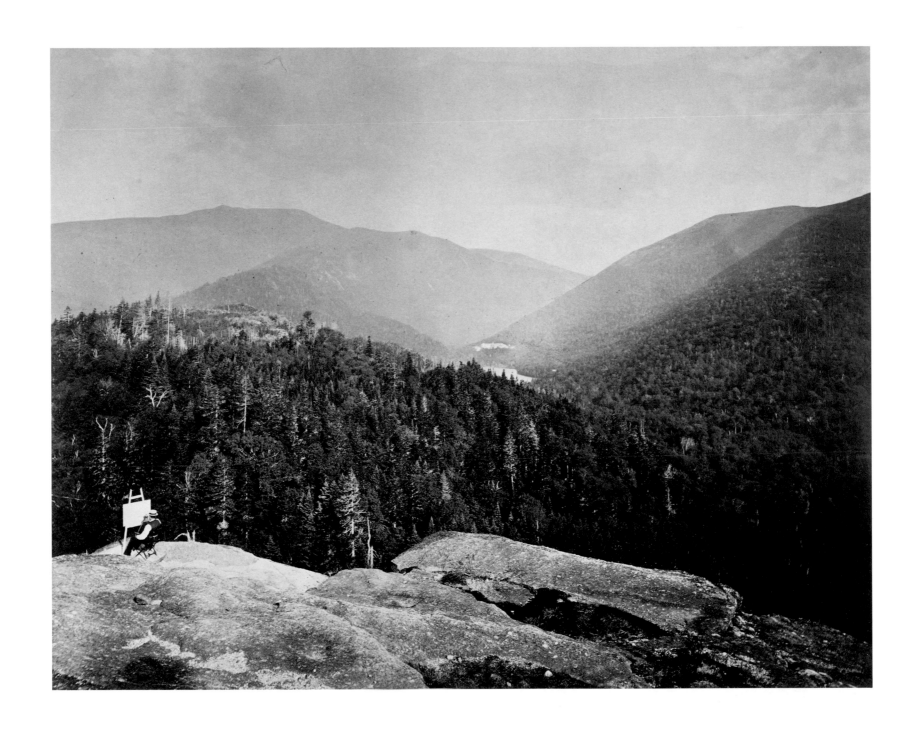

64 D. W. BUTTERFIELD, PROFILE HOUSE AND ECHO LAKE, NEW HAMPSHIRE, 1883

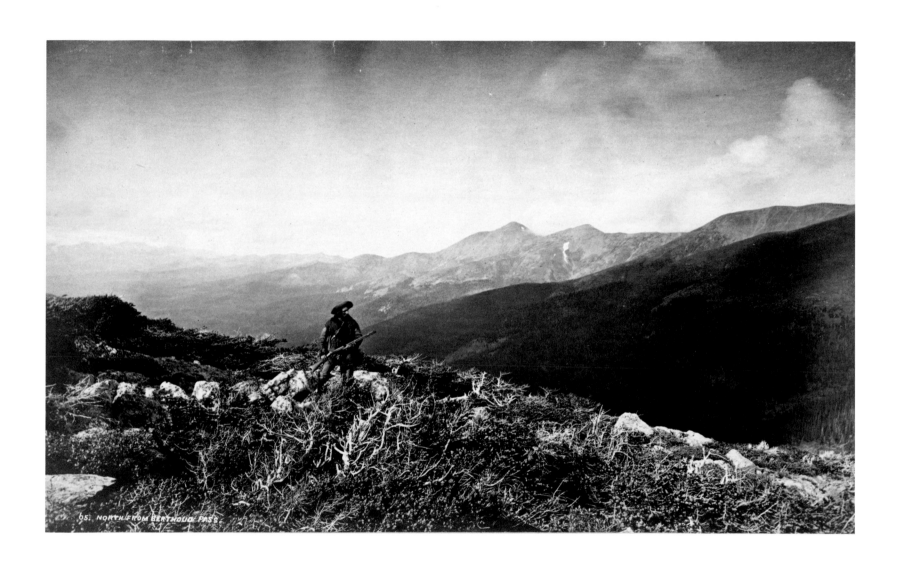

65 WILLIAM HENRY JACKSON, NORTH FROM BERTHOUD PASS, COLORADO, C. 1875

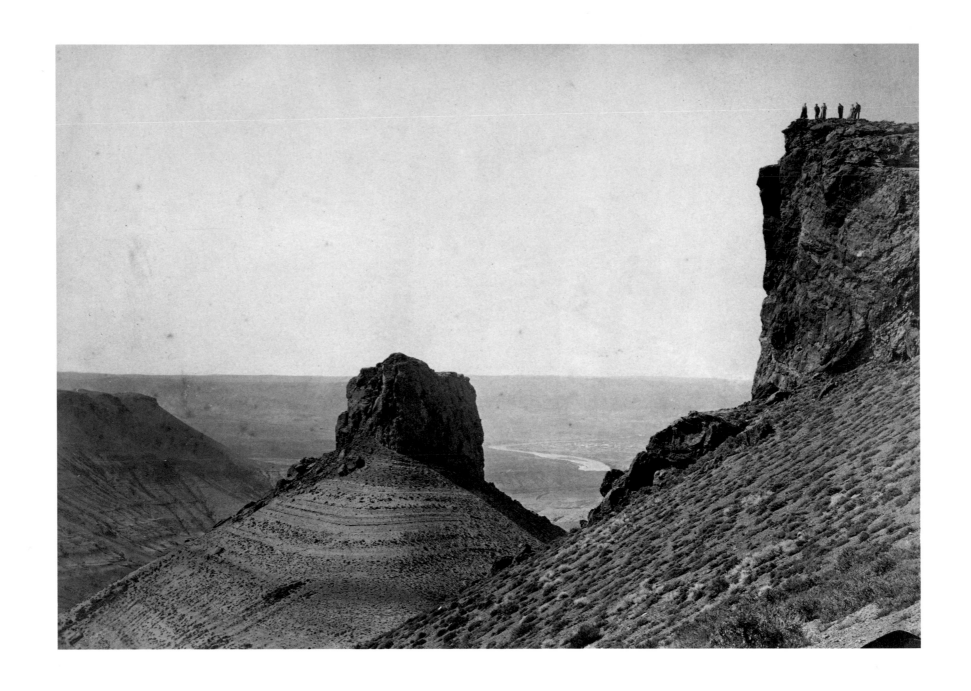

68 ANONYMOUS, UNTITLED (NEW ENGLAND), C. 1880

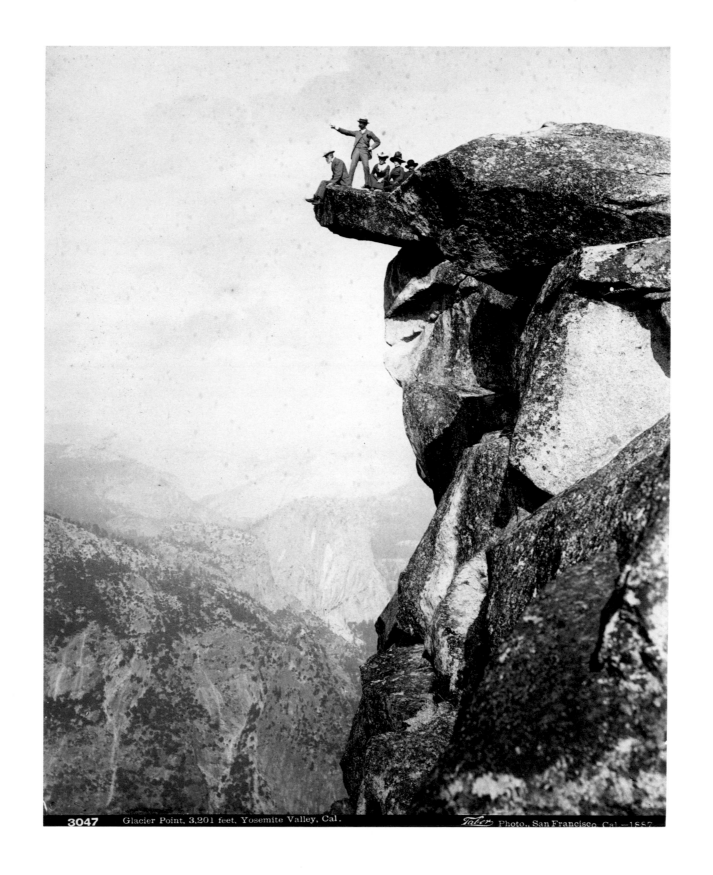

3047 Glacier Point, 3,201 feet, Yosemite Valley, Cal. *Taber* Photo., San Francisco, Cal.—1887

69 ANONYMOUS, GLACIER POINT, YOSEMITE VALLEY, CALIFORNIA, 1887

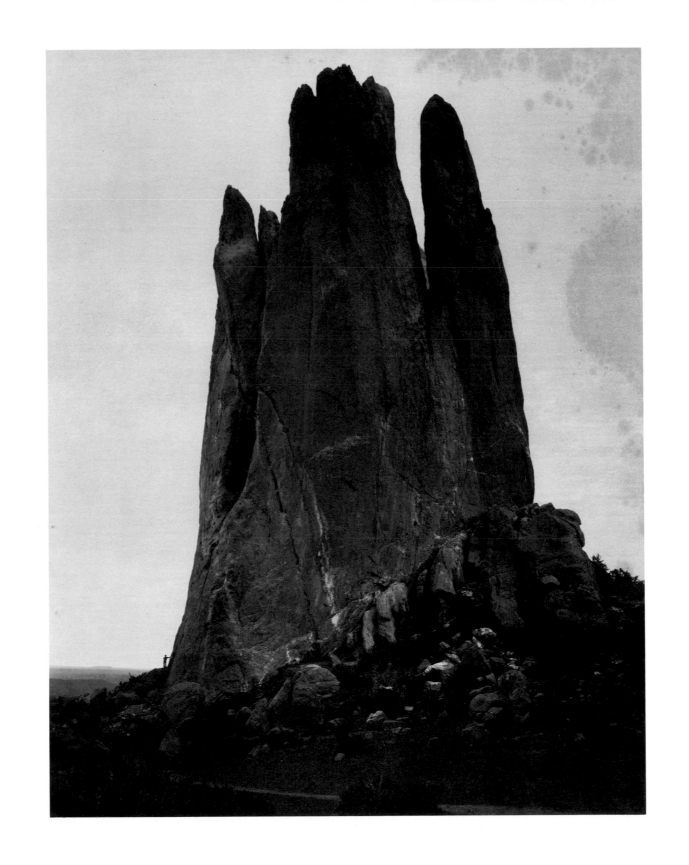

70 WILLIAM HENRY JACKSON, TOWER OF BABEL, GARDEN OF THE GODS, COLORADO, AFTER 1880

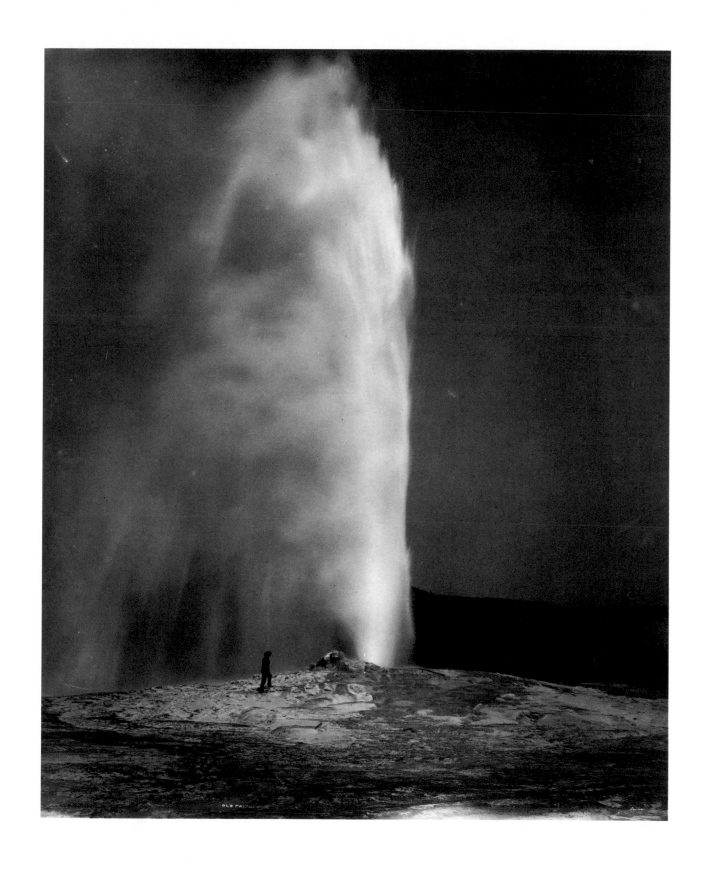

71 WILLIAM HENRY JACKSON, OLD FAITHFUL GEYSER, YELLOWSTONE, WYOMING, C. 1870

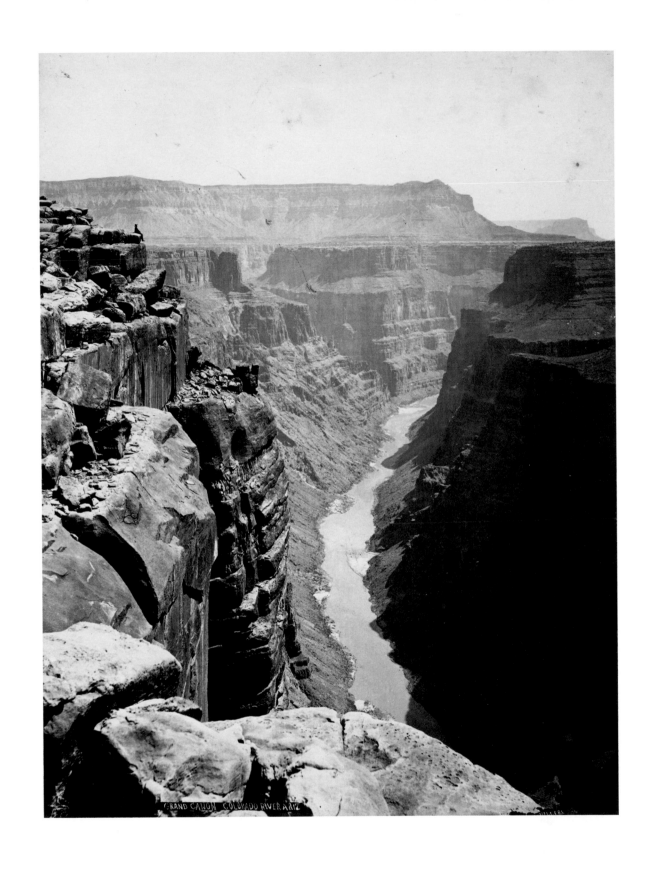

72 JACK HILLERS, GRAND CANON, COLORADO RIVER, ARIZONA, C. 1875

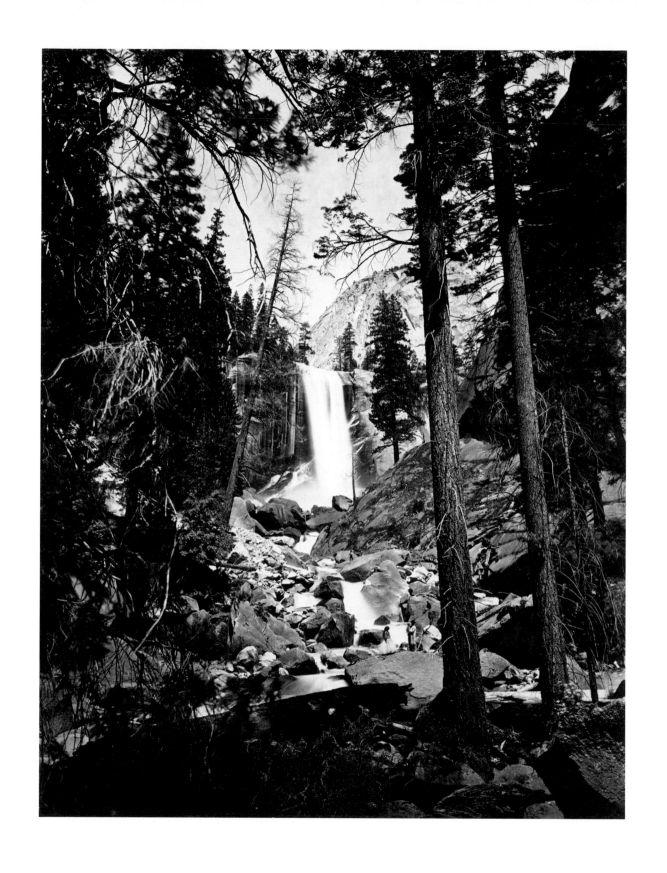

73 C. L. WEED, THE VERNAL FALLS, YOSEMITE VALLEY, CALIFORNIA, 1867

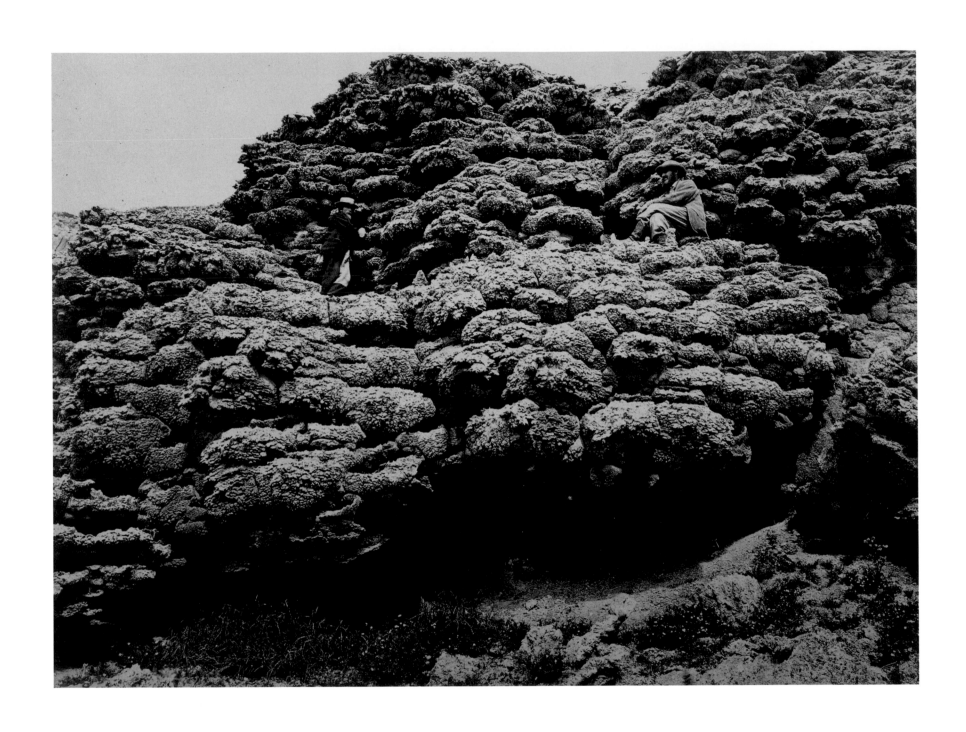

74 TIMOTHY O'SULLIVAN, MEN ON VOLCANIC RIDGE, C. 1868

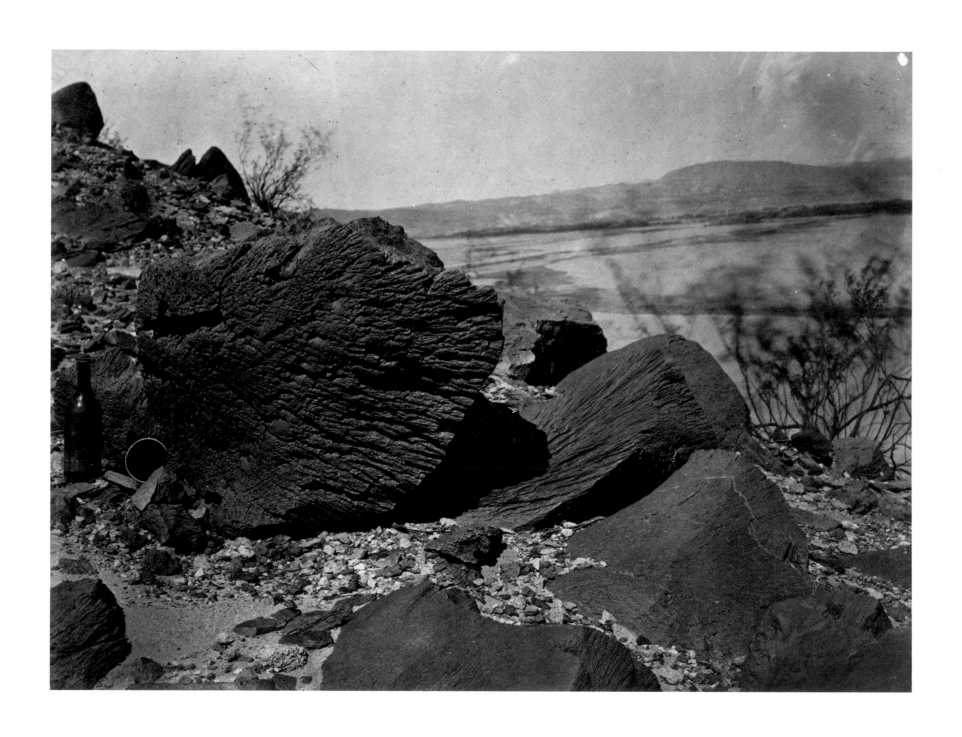

TIMOTHY O'SULLIVAN, ROCK CARVED BY DRIFTING SAND, BELOW FORTIFICATION ROCK, ARIZONA, 1871

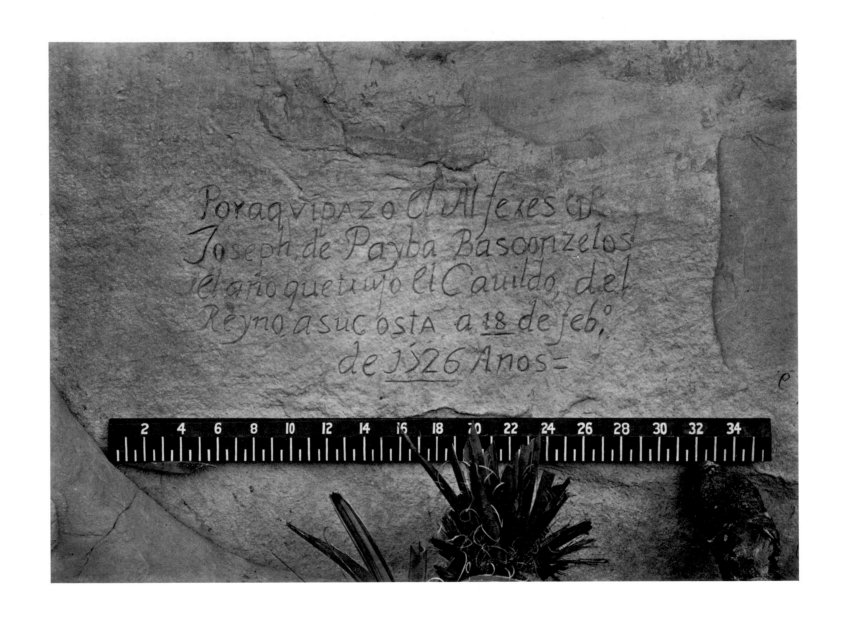

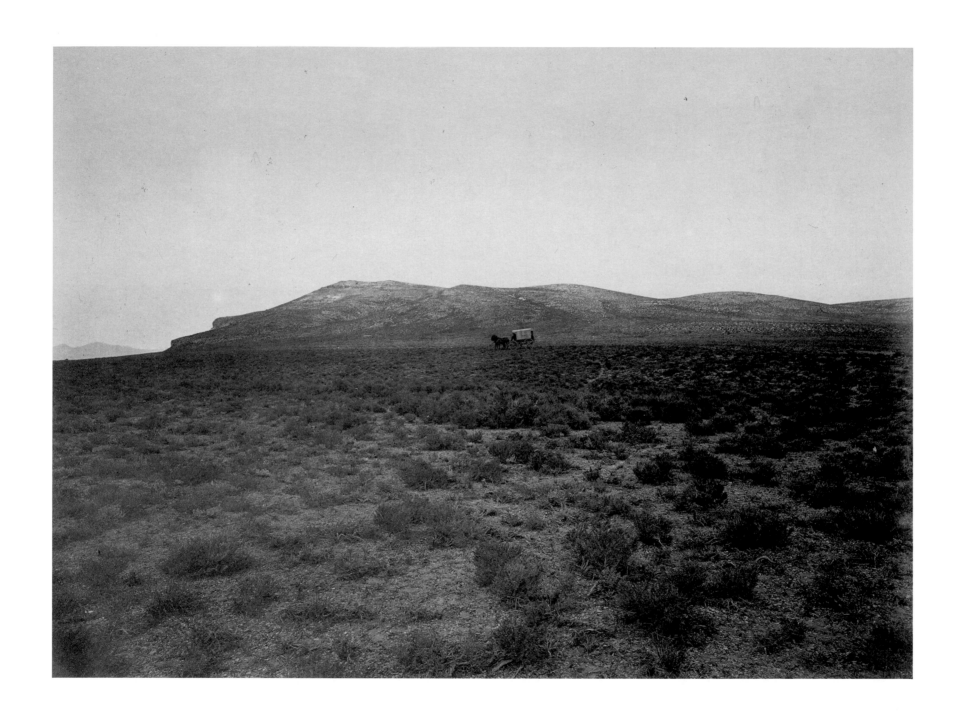

TIMOTHY O'SULLIVAN, SAGE BRUSH DESERT, RUBY VALLEY, NEVADA, C. 1868

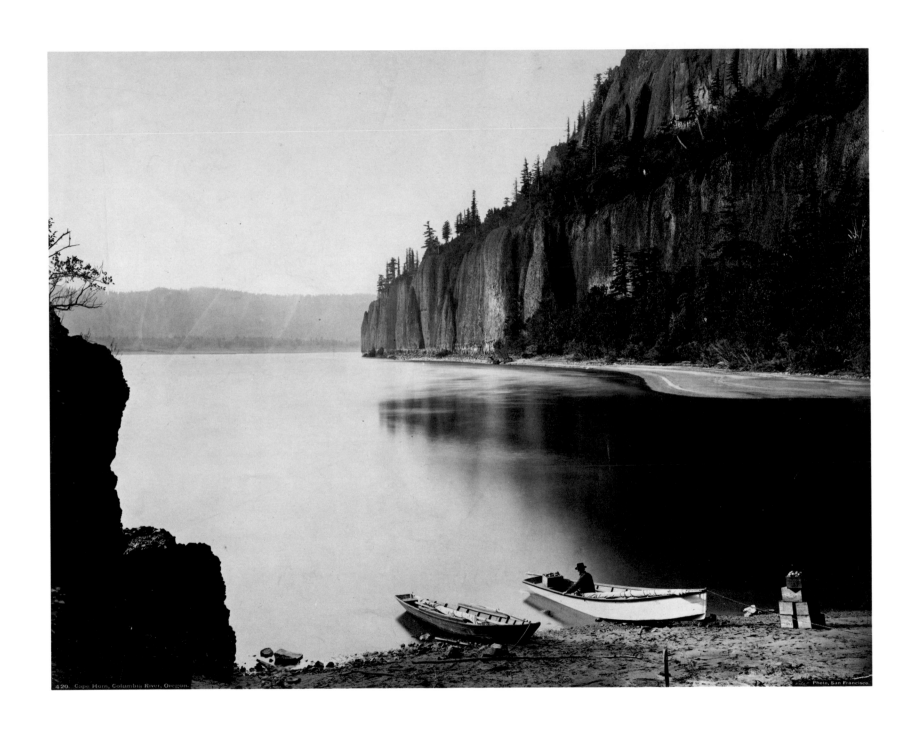

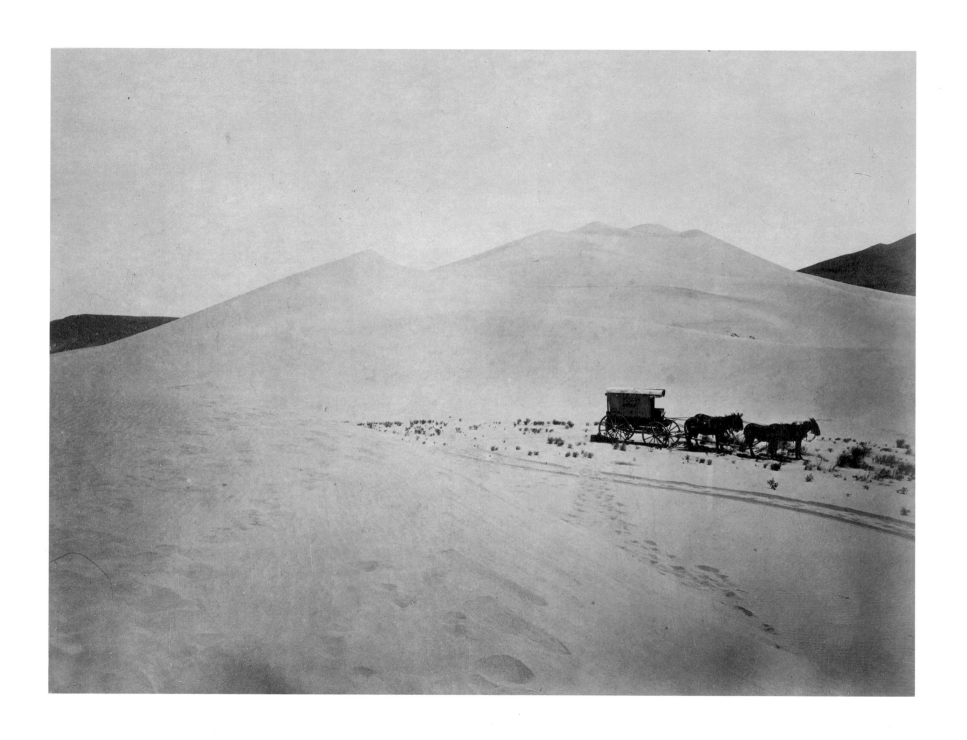

79 TIMOTHY O'SULLIVAN, DESERT SAND HILLS NEAR SINK OF CARSON, NEVADA, C. 1868

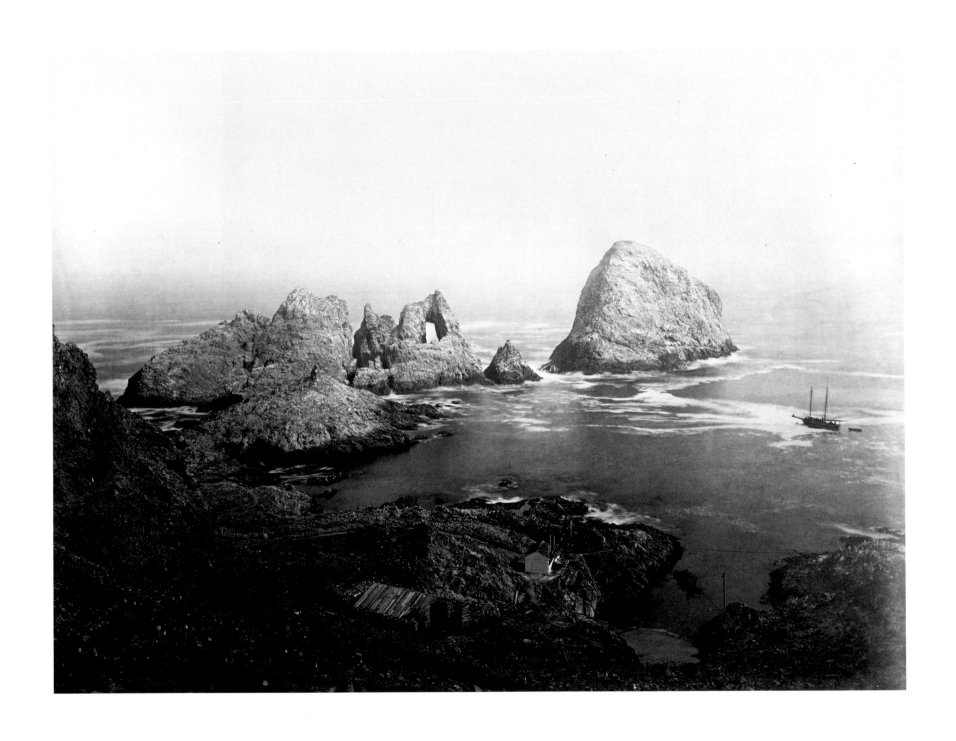

CARLETON WATKINS, SUGAR LOAF ISLANDS AND FISHERMAN'S BAY, FARALLONS, CALIFORNIA, C. 1870

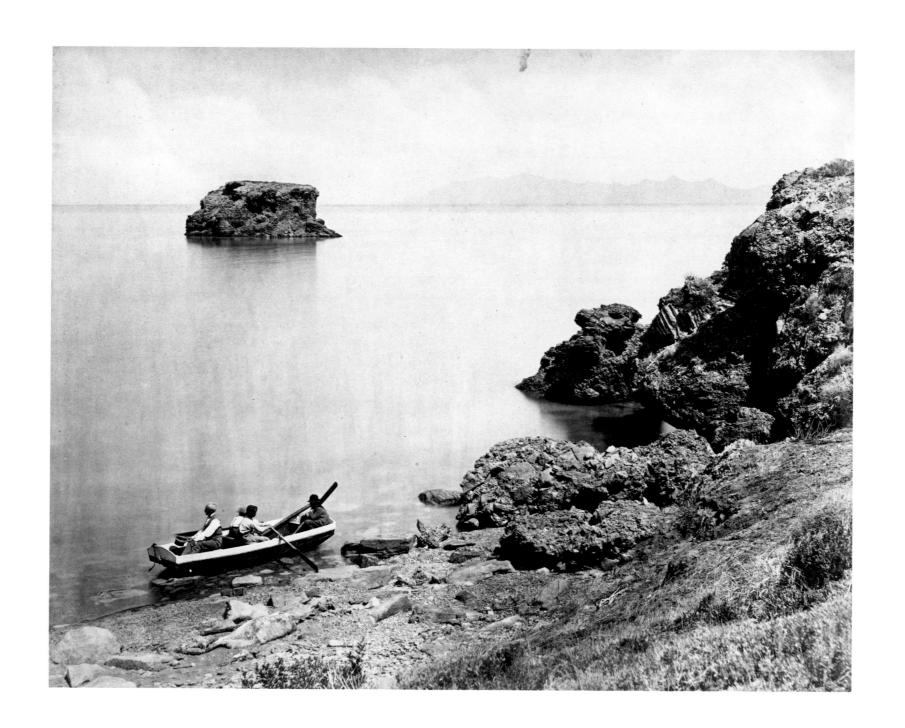

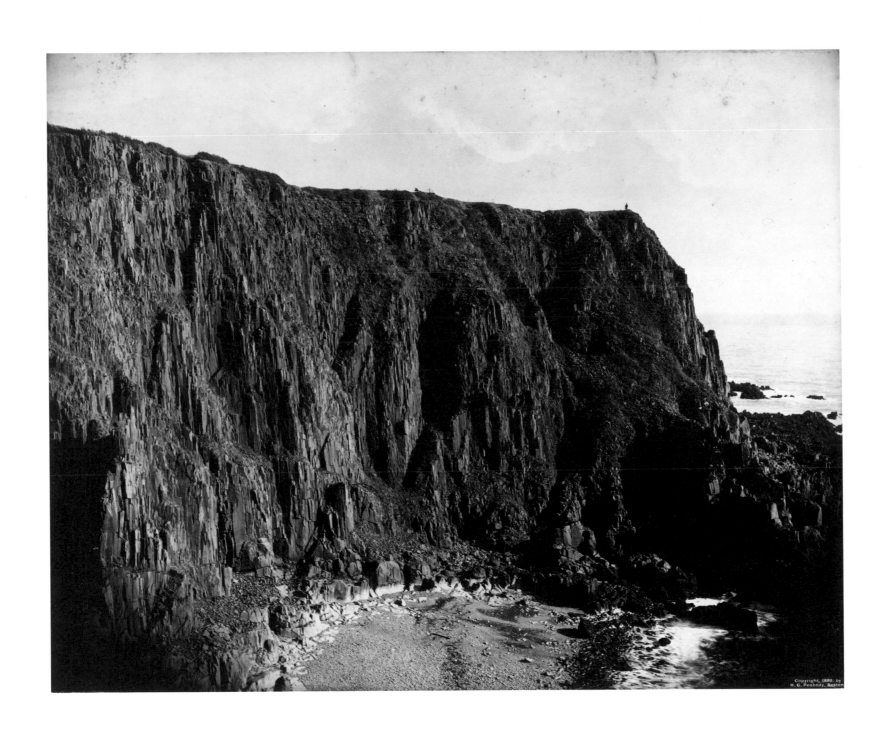

Copyright, 1889, by
H. C. Peabody, Boston

82 H. C. PEABODY, UNTITLED (NEW ENGLAND COASTLINE), 1889

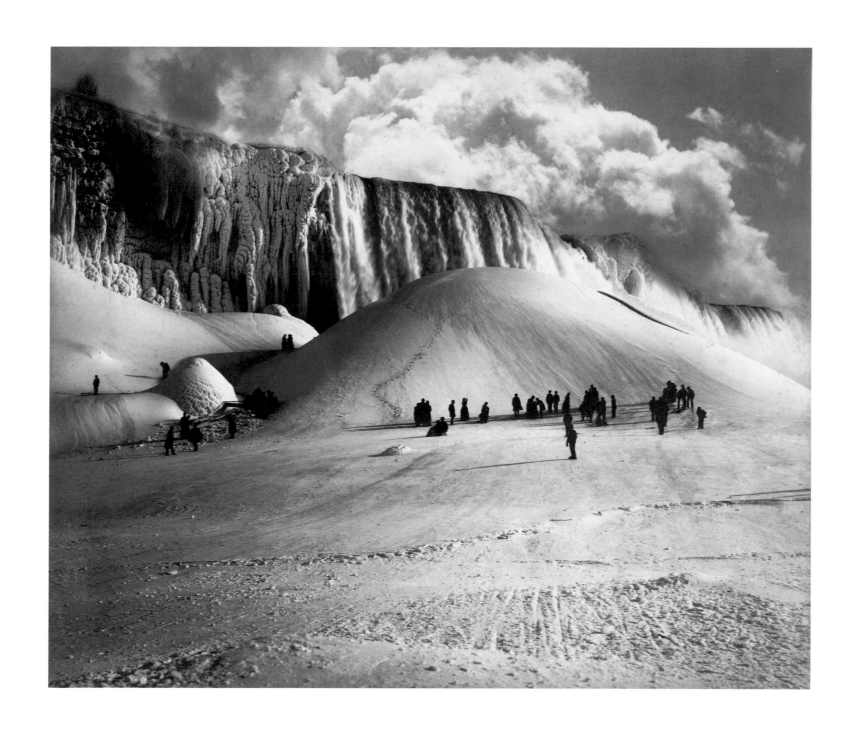

83 H. F. NIELSON, AMERICA NIAGARA FALLS, 1885

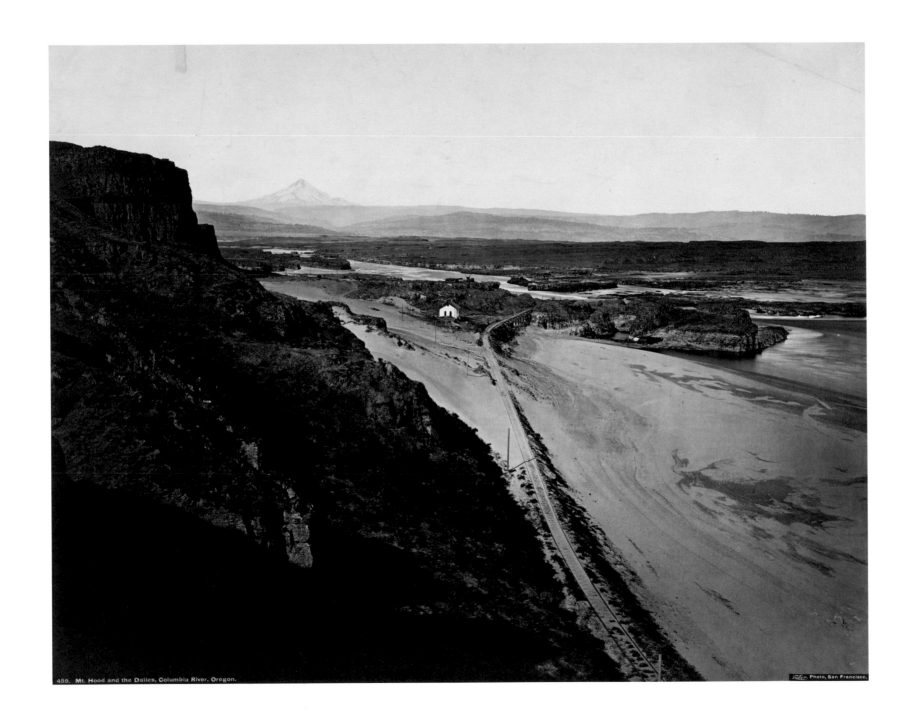

455. Mt. Hood and the Dalles, Columbia River, Oregon.

Photo, San Francisco.

84 CARLETON WATKINS, MOUNT HOOD AND THE DALLES, COLUMBIA RIVER, OREGON, C. 1867

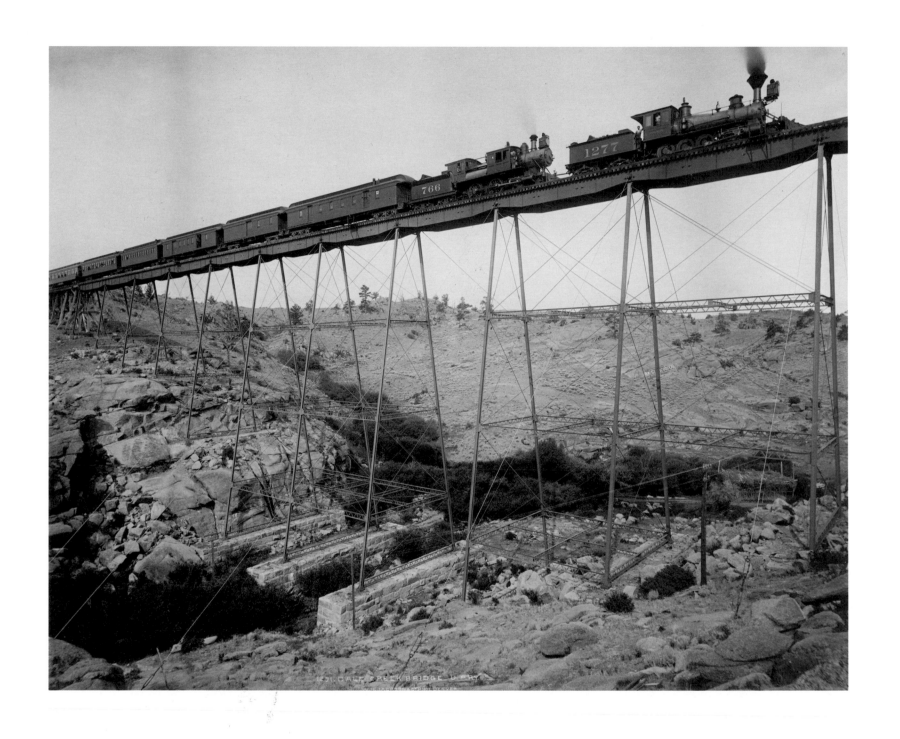

85 WILLIAM HENRY JACKSON, DALE CREEK BRIDGE, UNION PACIFIC RAILWAY, C. 1870

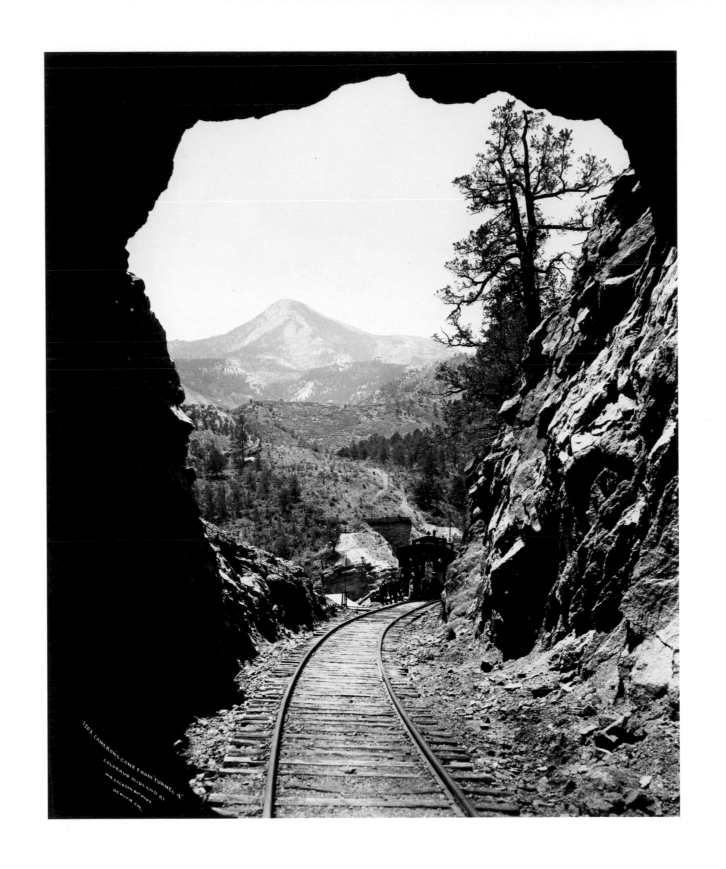

WILLIAM HENRY JACKSON, CAMERON'S CONE FROM 'TUNNEL 4,' COLORADO MIDLAND RAILROAD, AFTER 1880

87 ANONYMOUS, UNTITLED, C. 1885

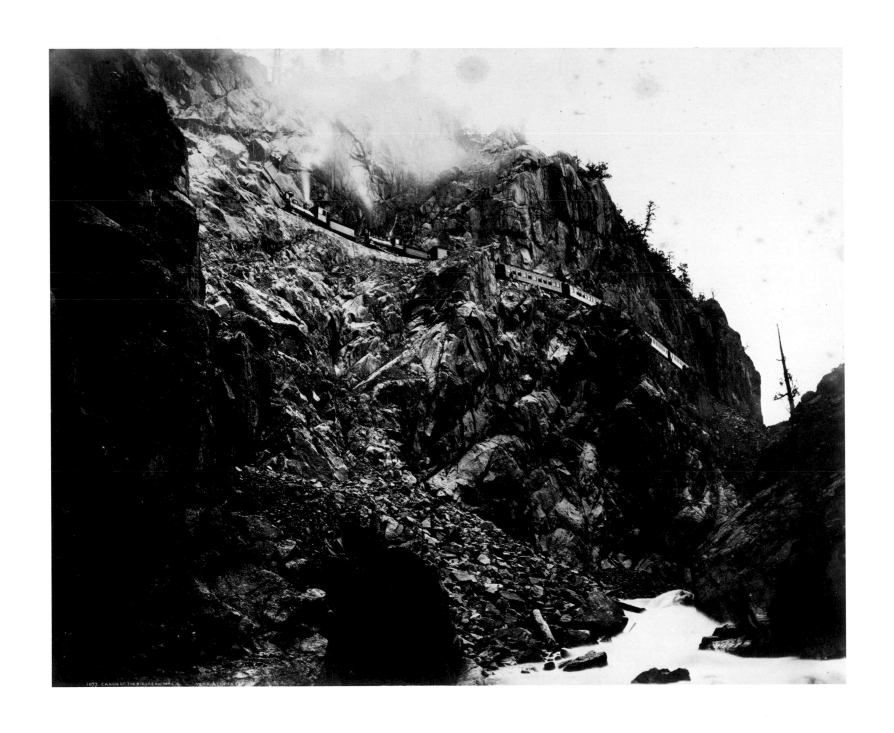

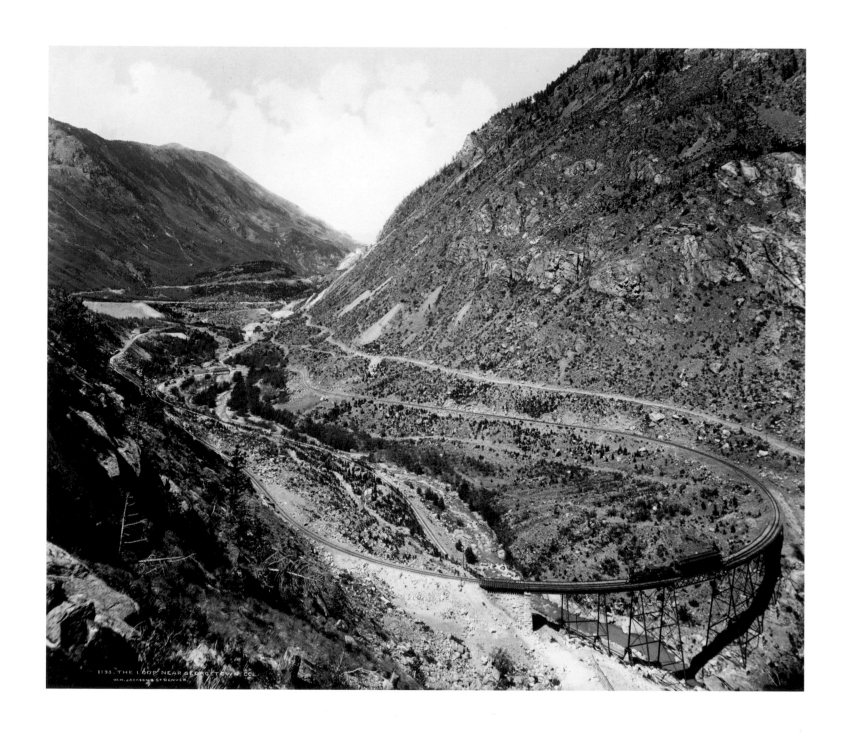

89 WILLIAM HENRY JACKSON, 'THE LOOP' NEAR GEORGETOWN, COLORADO, C. 1885

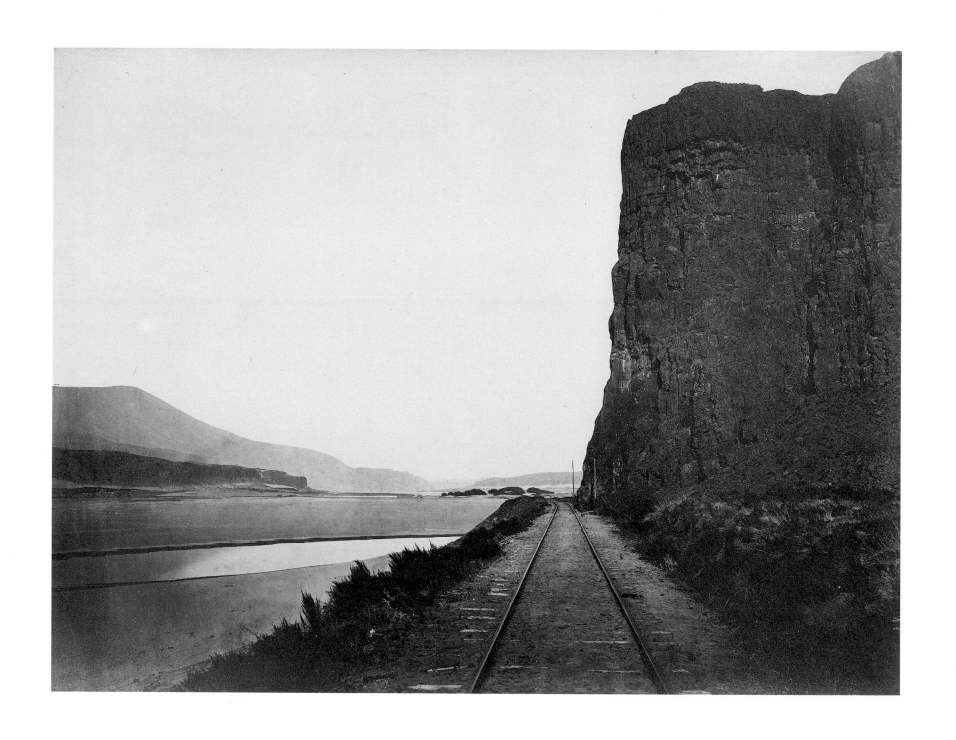

91 CARLETON WATKINS, CAPE HORN, OREGON, C. 1868

Coal Piers and Harbor, North Fair Haven. L. V. R. R.

WILLIAM H. RAU, PH.

92 WILLIAM RAU, LOWER GENESEE FALLS, NEAR ROCHESTER, NEW YORK, C. 1885

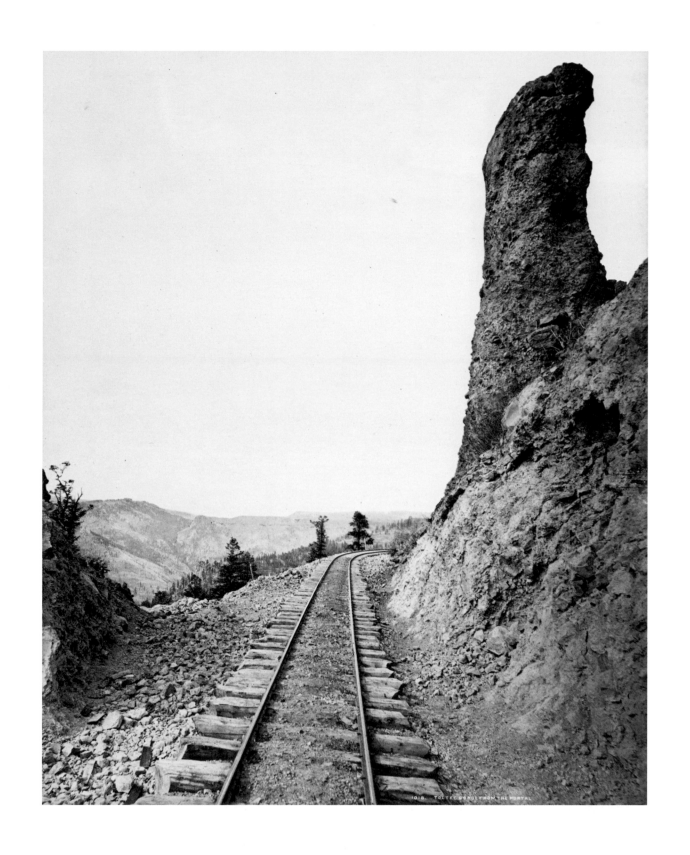

93 WILLIAM HENRY JACKSON, TOLTEC GORGE FROM THE PORTAL, C. 1880

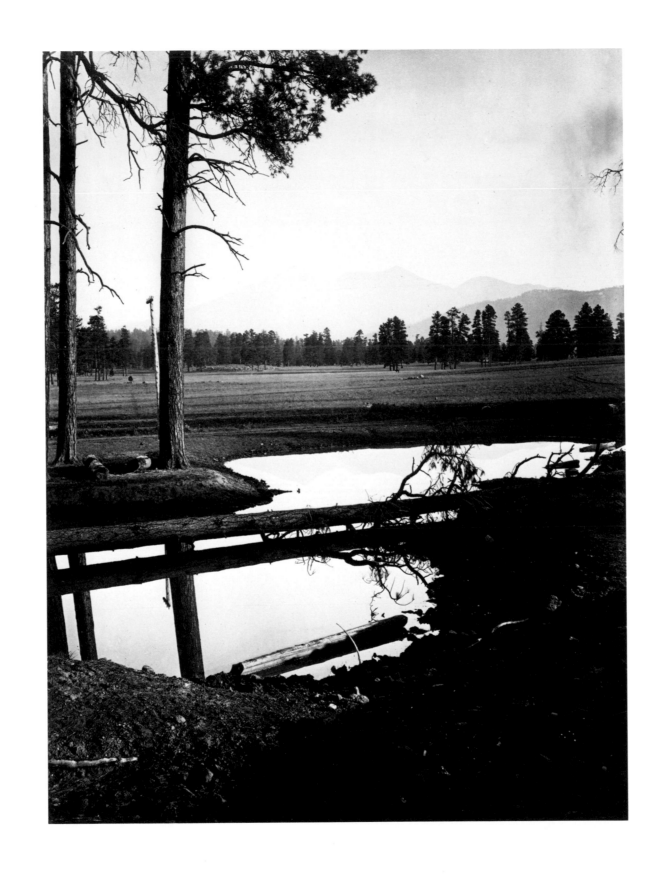

94 JOHN K. HILLERS, SAN FRANCISCO MOUNTAINS, C. 1872

95 WILLIAM RAU, WILKESBARRE, FROM POINT LOOKOUT, C. 1885

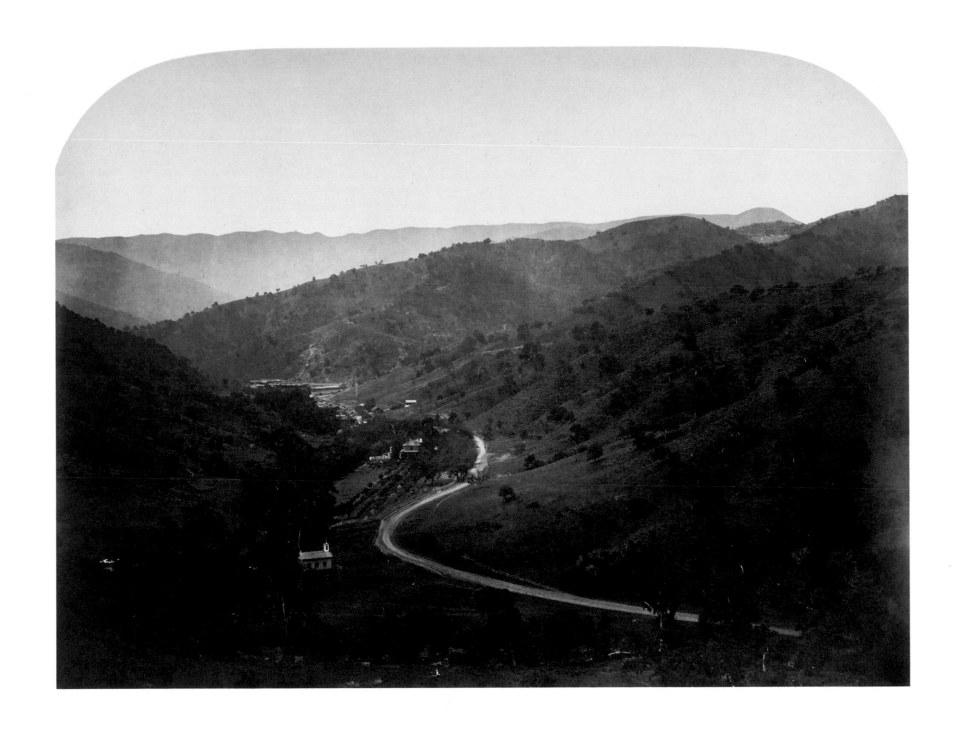

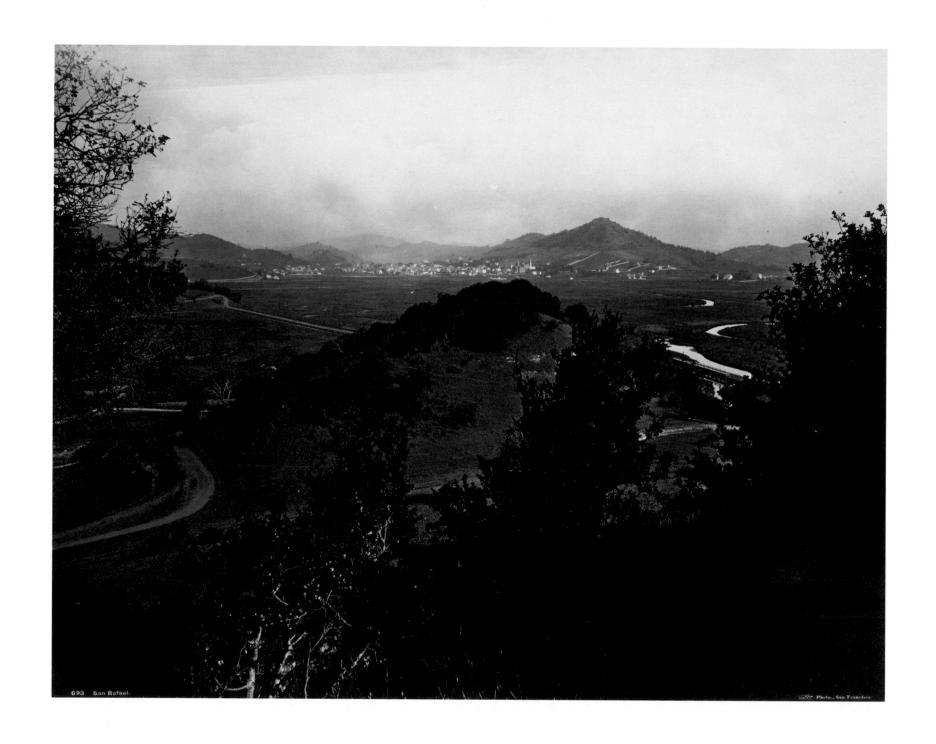

693 San Rafael.

Watkins Photo., San Francisco

97 CARLETON WATKINS, SAN RAFAEL, CALIFORNIA, C. 1880

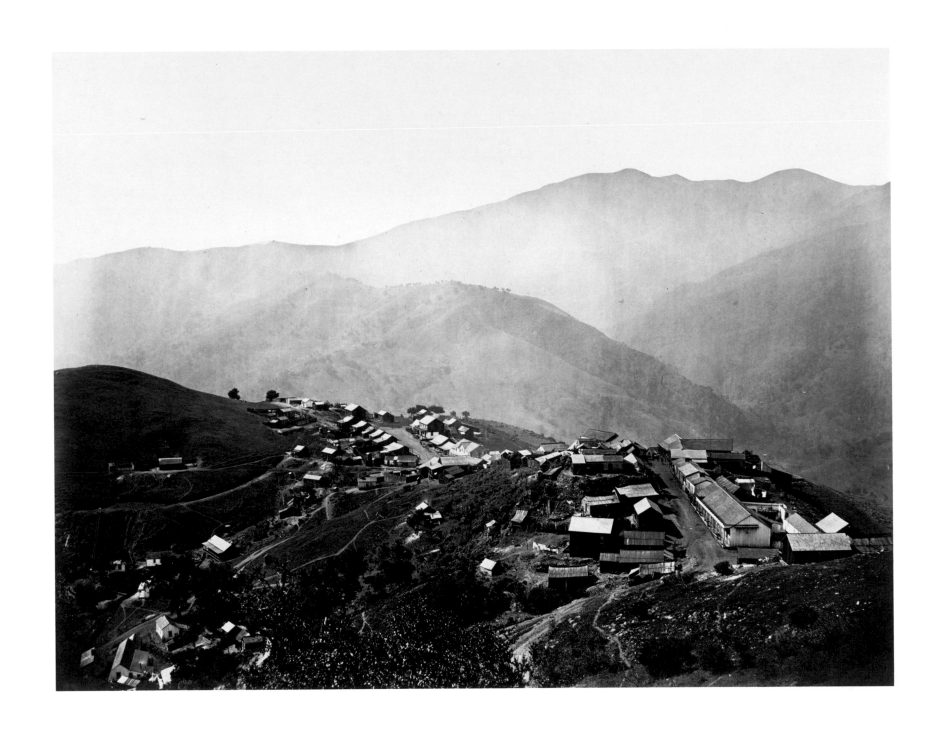

98 CARLETON WATKINS, THE TOWN ON THE HILL, NEW ALMADEN, CALIFORNIA, C. 1870

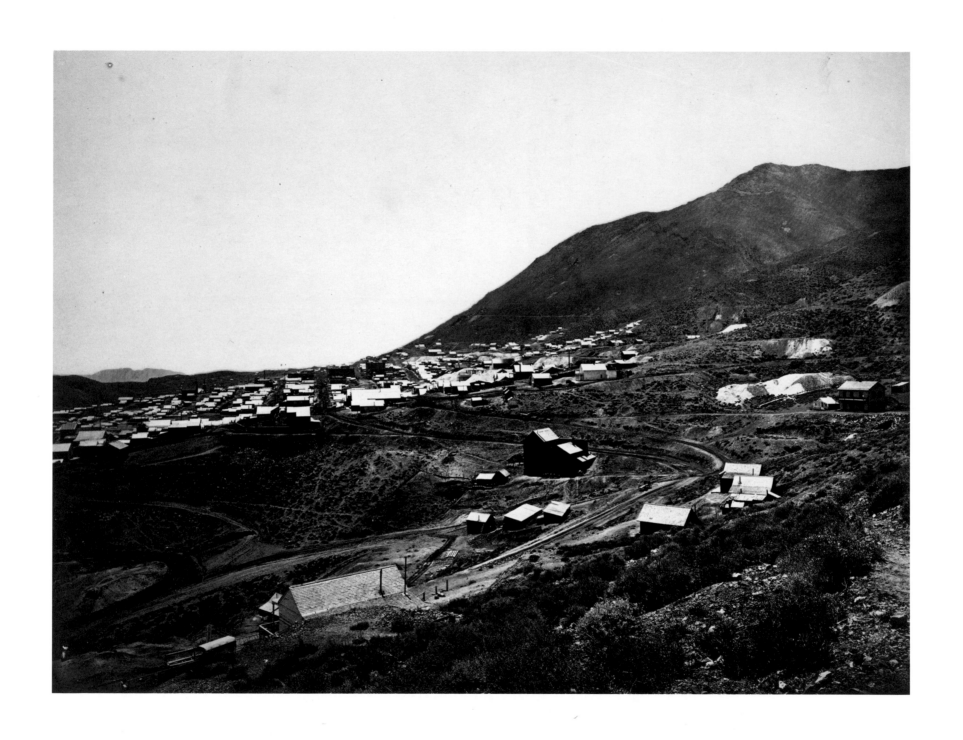

99 TIMOTHY O'SULLIVAN, THE KING EXPEDITION, VIRGINIA CITY, NEVADA, C. 1867

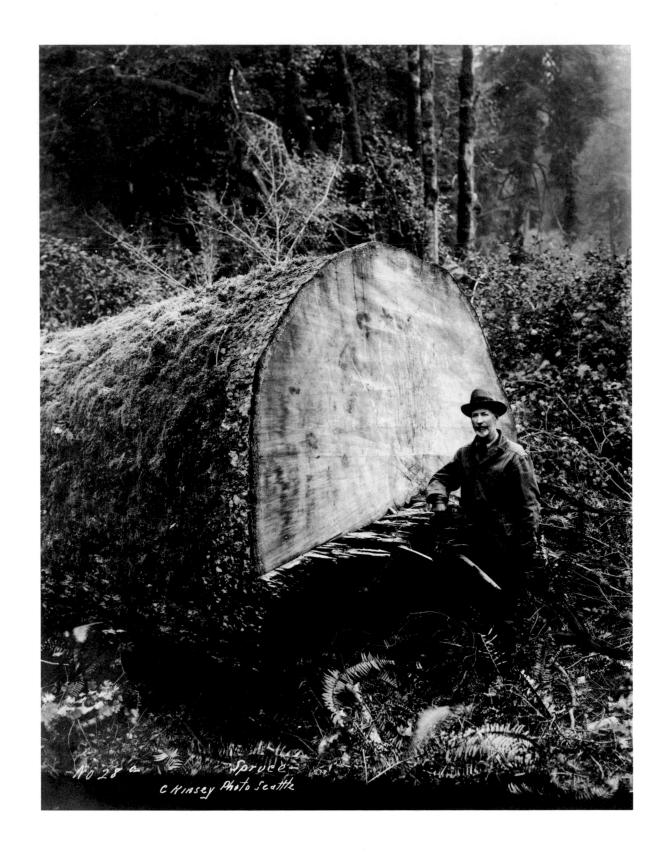

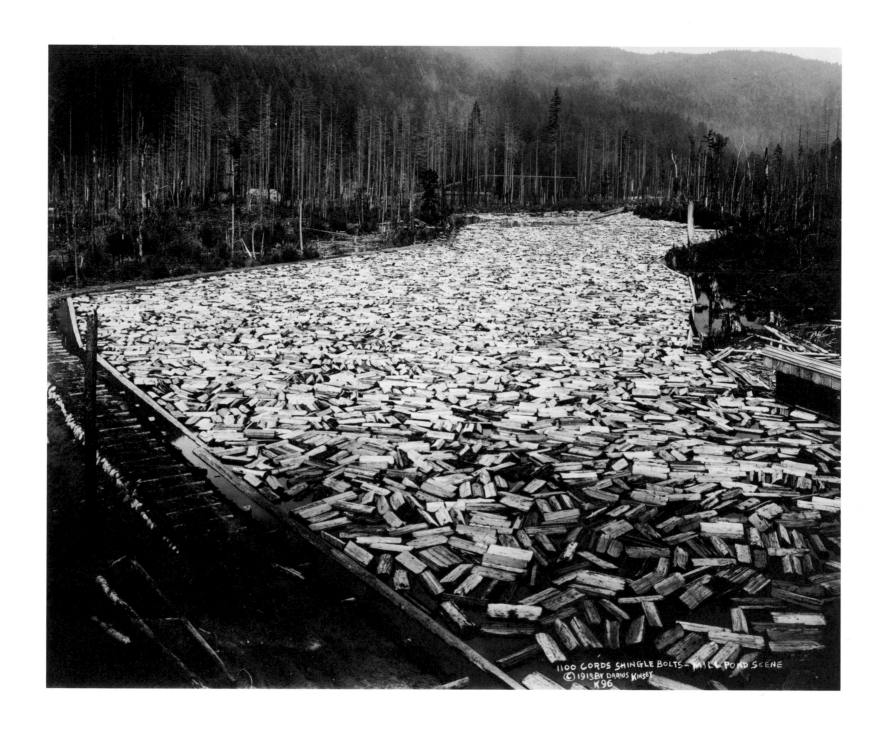

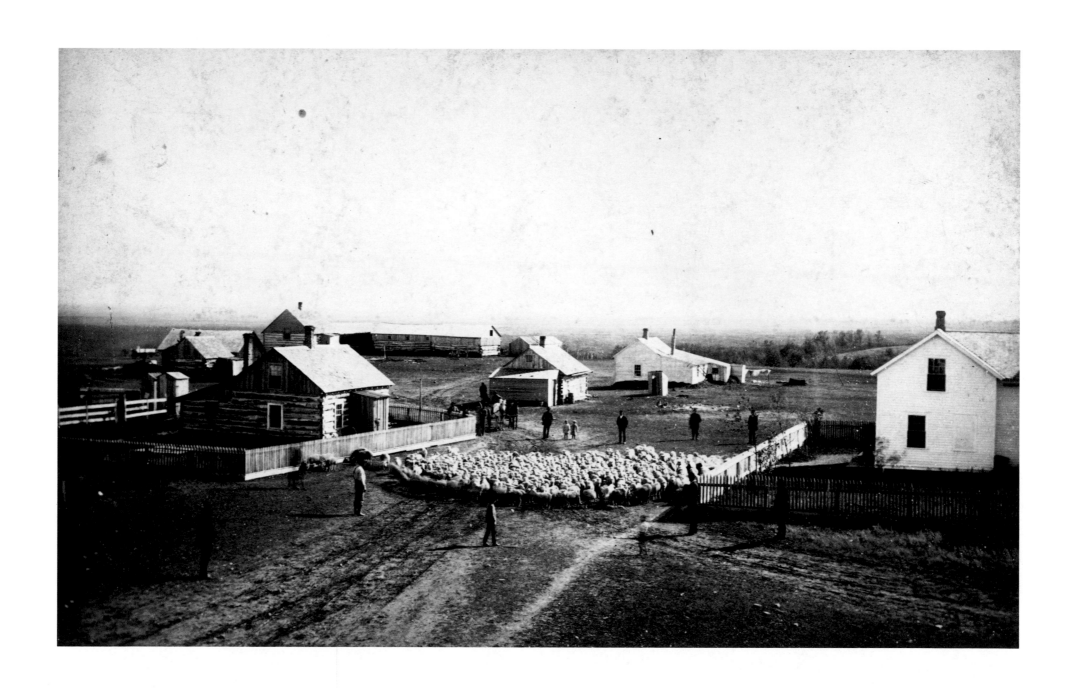

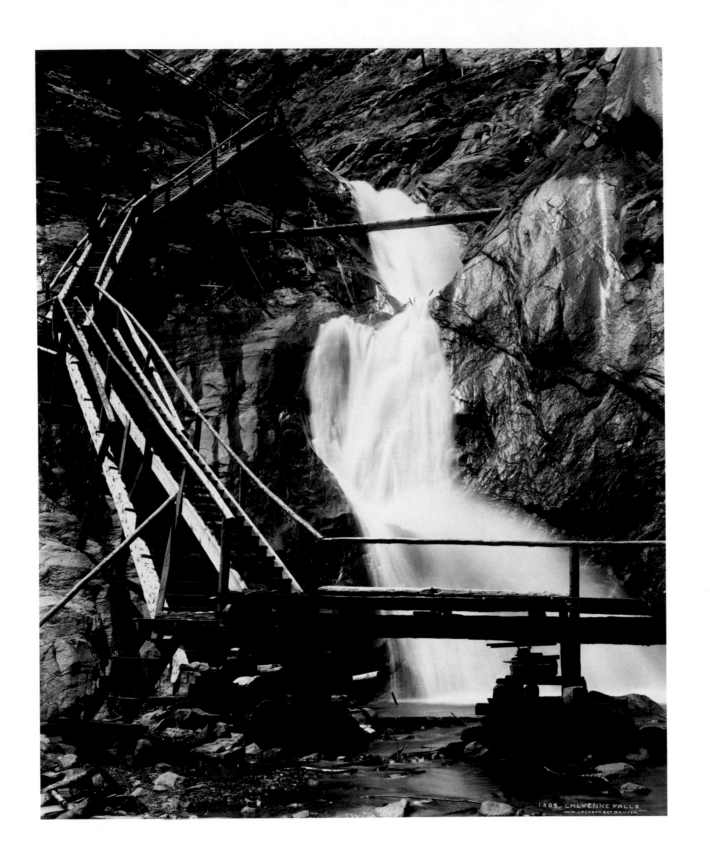

WILLIAM HENRY JACKSON, CHEYENNE FALLS, C. 1870

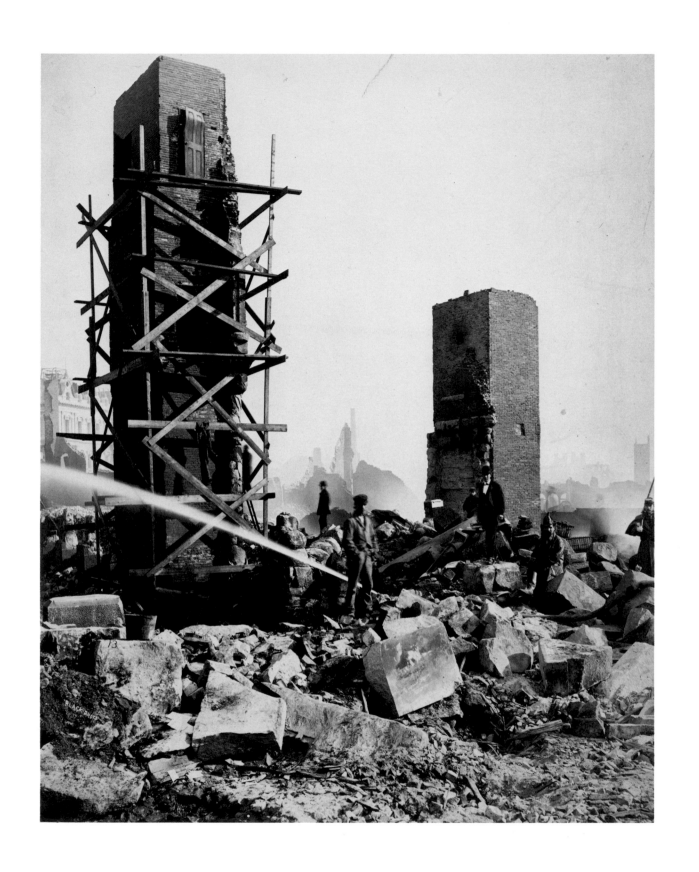

105 J. W. BLACK, UNTITLED (SAFE ON FRANKLIN STREET, BOSTON), C. 1868

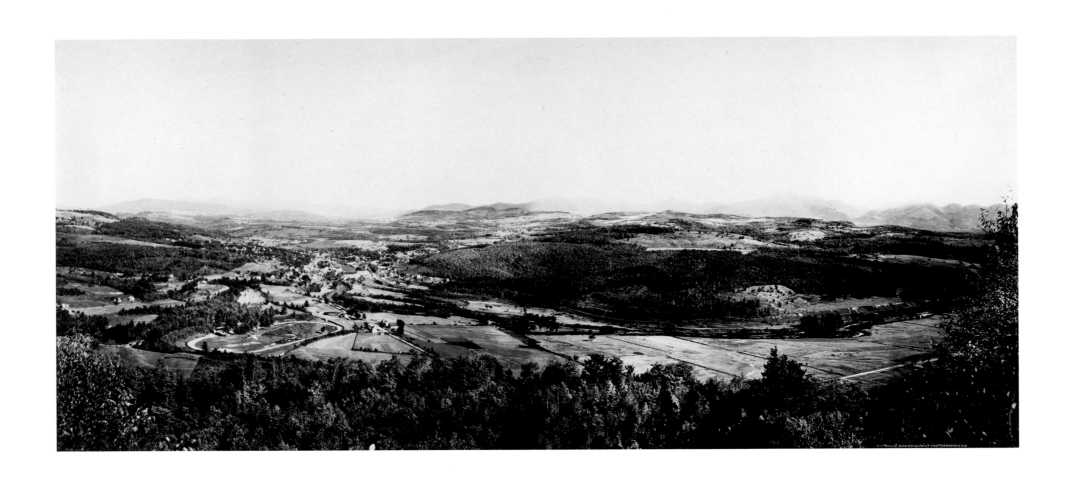

106 WILLIAM HENRY JACKSON, LITTLETON, WHITE MOUNTAINS, NEW HAMPSHIRE, 1900

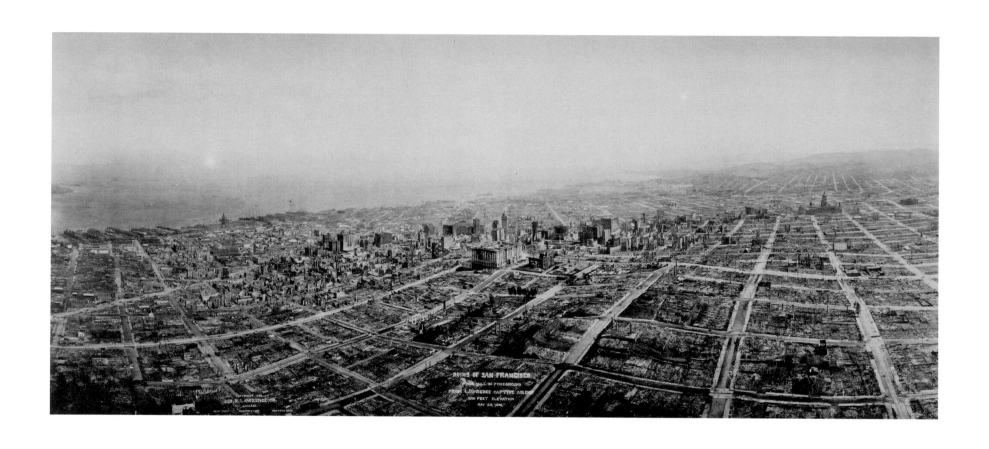

107 GEORGE E. LAWRENCE, RUINS OF NOB HILL, MAY 29, 1906

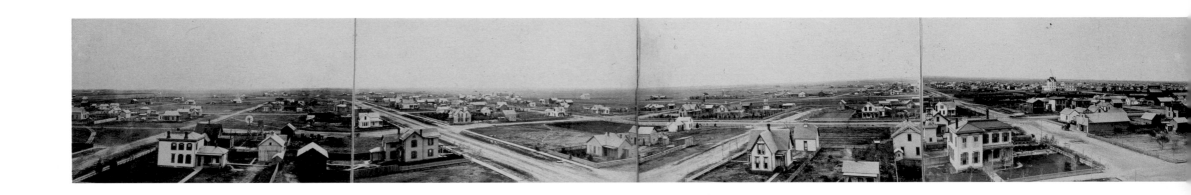

108–109 J. R. MOELLER, GRAND ISLAND, NEBRASKA, 1885

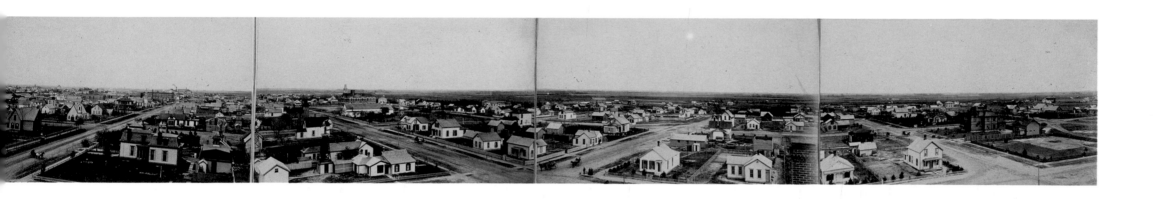

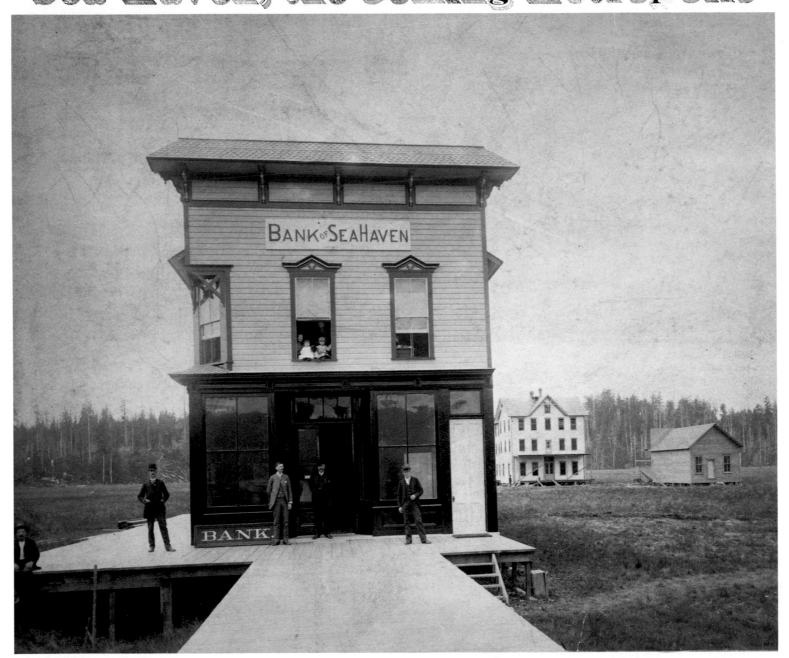

NOTES ON THE PHOTOGRAPHERS

JOHN K. HILLERS arrived in America at the age of nine, from Hanover, Germany, where he had been born in 1843. He served in a naval brigade, in the Union army during the Civil War, and reenlisted to serve at western garrisons until 1870. At this time Hillers joined his brother on a trip to San Francisco. Within one year he had settled in Salt Lake City where he worked as a teamster. There he chanced to meet John W. Powell, of the United States Geographical Survey. Hillers joined Powell's expedition down the Green and Colorado rivers as a boatman. On this trip Hillers became interested in photography. He joined Powell's next survey, in 1874, as the chief photographer and was the first man to photograph the Grand Canyon. Between 1875 and 1879 Hillers took field trips to Oklahoma, Arizona, and New Mexico for both the U.S. Geographical Survey and the Department of Ethnology. In 1900 he retired from an administrative job in Washington. He died in 1925.

TIMOTHY H. O'SULLIVAN was born in 1840 in New York. While in his teens he worked at Mathew Brady's Fulton Street Gallery. At the age of twenty-one he traveled with Brady's photographic corps to record the Civil War. Until 1862 O'Sullivan photographed chiefly in South Carolina. Then in 1863 he was employed by Alexander Gardner. After the war he helped Gardner compile his *Photographic Sketch Book of the War*. O'Sullivan left New York for San Francisco in 1867 with King's Fortieth Parallel Survey. Three years later he accompanied Lieutenant Commander Selfridge's Darien Expedition to Panama. He was the official photographer for Wheeler's 100th Meridian Survey in Arizona, New Mexico, Utah, and Idaho from 1871 until 1874. He left this survey for only one season, to join King's Montana survey. Late in 1874 O'Sullivan traveled to the Canyon de Chelly. He returned to Baltimore in 1875 to print an album of photographs from Wheeler's survey. In 1882 O'Sullivan died of tuberculosis.

CARLETON E. WATKINS was born in 1829 in upstate New York; by the time of the gold rush he had moved to San Francisco. He learned to photograph in Robert Vance's daguerreian studio about 1854. In 1861 Watkins made his first trip to Yosemite with a large camera made for him by a San Francisco cabinet maker. His mammoth plates (18 by 24 inch negatives) were praised highly, but none were copyrighted until 1867. That same year Watkins opened his own Yosemite Art Gallery. Also in 1867 the painter William Keith traveled with Watkins to northern California and Oregon. He became acquainted with Clarence King of the Fortieth Parallel Survey and in 1870 journeyed with King to Mounts Shasta and Lassen. In 1873, again with Keith, Watkins photographed in Utah and along the route of the Central Pacific Railroad. Watkins was forced to declare bankruptcy during the financial panic of 1873–1874 and forfeited all of his negatives to his creditors. Eventually these negatives fell into the hands of I. W. Taber. After photographing further in Yosemite, Watkins made his first trip to southern California. By 1890 his eyesight was failing. In 1906 Watkins was totally blind, and the San Francisco earthquake and fire destroyed all of his work in his studio. Carleton Watkins died in an asylum in 1916.

HENRY HAMILTON BENNETT was born in Canada in 1843, but he spent most of his childhood in Vermont. In 1857 he traveled to Kilbourn City, Wisconsin, with his father, seeking a new home for their family. During the Civil War, Bennett joined a local Wisconsin regiment and fought until 1864. At the age of twenty-two he returned to Kilbourn with a crippled right hand and bought a local photography business. Although at first his business failed, eventually Bennett began to attract customers. 1868 was his first year of landscape photography; most of his photographs were stereoscopes. Business continued to flourish, and in 1875 a Milwaukee businessman, William Metcalf, gave Bennett the funds for a new studio. In the years to follow, he traveled throughout the state photographing and held exhibitions in several other states. Bennett died in 1908.

EADWEARD J. MUYBRIDGE was born in Kingston-on-Thames, England, in 1830. By 1855 he had moved to San Francisco and was the proprietor of a bookstore. As an amateur, he began to take photographs of daily life in San Francisco. A stagecoach accident in 1860 forced Muybridge to return to England. But while in England he became a skilled photographer. In 1868 Muybridge copyrighted his first views of Yosemite, and by this time he had also traveled to Alaska. Fifty-one of Muybridge's

mammoth plates of Yosemite and the Sierra Nevada were copyrighted in 1872. Also in 1872 he met Leland Stanford and began an experiment to photograph Stanford's horse, Occident, while galloping. Muybridge killed his wife's lover in 1874, and fled to Central America the following year. From 1877 until 1881 Muybridge conducted photographic experiments on motion with the help of Stanford. Subsequently, Muybridge toured Europe, then returned to his home, Kingston-on-Thames. Muybridge died in 1904.

WILLIAM HENRY JACKSON, born in 1843, took his first trip west as a "bullwacker" with a wagon train in 1866. He did not begin to photograph until he opened his own studio in 1867 in Omaha. As a railroad photographer, Jackson traveled west of Omaha in 1869. From 1870 until 1878 he worked for F. V. Hayden's survey, creating, in 1875, his first mammoth plates (20 by 25 inches). Jackson used only dry plates for his series of Yellowstone photographs made in 1878. One year later he founded the Jackson Photographic Company in Denver, where he did most of his work until his death in 1942.

ADAM CLARK VROMAN was born in 1856 in La Salle, Illinois. He worked as a railroad man for seventeen years in Rockford, Illinois. Vroman was married in 1892 and moved to Pasadena, California, for his wife's health. After a journey back to his wife's family in Pennsylvania, where his wife died, Vroman settled in Pasadena and became the proprietor of a bookstore. As an avid amateur photographer, Vroman made his first trip to Arizona in 1895. Soon thereafter he began working for the Bureau of American Ethnology, traveling with them as the official photographer for two expeditions to the Southwest. Vroman continued to photograph in the region until his last trip to the Canyon de Chelly in 1904. In 1909 Vroman visited Japan and the Far East in order to collect oriental art. In 1916 Vroman died in Altadena, California.

ANDREW JOSEPH RUSSELL was born in Nunda, New York, in 1830. As both painter and photographer, he set up his first studio in New York City. During the Civil War, Russell photographed on the staff of General A. Haupt. After the war he traveled frequently between his family home in the east and his new home in Omaha. In 1867 he became the official photographer for the Union Pacific Railroad. At some point before 1869 Russell also made portraits of a family in Nunda; he photographed for one season in 1869 with the King survey. By 1891 Russell's eyes were failing him. He died in Brooklyn in 1902.

WILLIAM ABRAHAM BELL was a member of the British gentry and a dabbler in the arts who lived in Philadelphia. In 1863 he began to take a series of medical photographs of the Civil War. Late in 1867 these photographs were published in a book on the medical history of the war. In 1868 Bell joined a western survey team as a photographer, and in 1872 he traveled with George A. Wheeler's expedition.

GLOSSARY OF PHOTOGRAPHIC PROCESSES

CYANOTYPE OR BLUEPRINT

Sir John Herschel invented the cyanotype in 1842. It is a fairly simple, practical process that results in prints with a bright, Prussian-blue tint. A paper base is brushed with a solution of ammonio-citrate of iron and potassium ferricyanide. The paper is allowed to dry in the dark, then a contact print is made in daylight. A pale green image appears on the paper and when washed in water it turns to bright blue. The image requires no chemical fixing and is permanent. Some photographers toned the prints but this was an unpredictable process with the cyanotype. Since this is a type of salt print, the image is embedded in the paper and appears matte.

ALBUMEN PRINT

The most widely used method of printing between 1850 and 1880, the albumen print was invented by Louis Désiré Blanquart-Evrard. Albumen, or fresh egg white, was used to coat thin, high-quality writing paper. On top of the albumen was brushed a solution of acidified silver nitrate. Once exposed to light this paper was fixed with sodium thiosulphate, or "hypo," and washed in water. In good condition these prints have a brown or russet tint. However, photographers frequently fixed them in gold chloride for a more purplish tone. Because of the emulsion, the image appears to rest on the surface of the print, and is not interrupted by the grain of the paper. Albumen prints were made from various types of negatives; paper or waxed paper negatives were used until 1851 when wet collodion negatives became popular.

WET COLLODION PROCESS

Wet collodion negatives were perfected in 1851 and were widely used until the development of dry plate negatives in 1880. Collodion is a mixture of guncotton (pyroxyline), ether, and alcohol, which was brushed on a clean plate of glass. Bromide and iodide salts were dissolved in the collodion before this application. When the emulsion had set, the plate was coated with or immersed in a solution of silver nitrate. While still wet the negative was exposed and developed, usually in a protosulfate or iron developer. Sodium thiosulphate or "hypo" was used to fix the image, and the glass plate was then washed in water. Usually the negatives were coated with varnish in order to prevent scratching and decomposition. While this process provided minute details and an extensive range of tones, it was also very awkward. The negatives had to remain wet and in the dark during the preparation and development. Photographers had to travel with large tents and heavy plates of glass. Thus, as soon as dry plates became available, the wet collodion process was virtually abandoned.

GELATIN DRY PLATES

The first published experiments with gelatin dry plates appeared in 1871, and by 1878 commercially made dry plates were widely available. Glass plates were coated with a gelatin emulsion containing silver halides. This emulsion never completely dried out. Dry plates could be used anywhere as long as they were stored in darkness. Often it is not apparent whether a print has been made with a wet collodion or a dry plate negative, unless the edges of the emulsion are shown on the print. But the method of printing also changed in the 1880s. Usually wet plate negatives were printed on albumen paper, and gelatin silver or printing out paper was used with dry plate negatives.

PLATINOTYPE OR PLATINUM PRINT

As early as 1832 platinum was known to be a very stable, light-sensitive substance, but it was not until 1873 that William Willis suggested a method for making platinum printing paper. In 1879 the Platinotype Company was founded, making platinum paper readily available to photographers. Fine paper was sensitized with a coating of potassium chloroplatinate and ferric oxalate. Once dried, this paper appeared slightly yellowed. After a contact negative was made on the paper, the image partially appeared in a grey to brown tint with orange highlights. Further development in potassium oxalate served to dissolve the ferrous oxalate and precipitate metallic platinum. This final image was fixed and washed in a weak bath of hydrochloric or citric acid, and then in water. The platinotype image was just as permanent as its paper base. Platinum prints, when untoned, are silver-grey in color, and provide a very full range of greys and middle tones. The image, as in all salt prints, appears embedded in the paper, not just on the surface, and is always matte.

SUGGESTED READING

Cather, Willa. *My Antonia*. New York, 1918.

Cole, Thomas. "Essay on American Scenery." *The American Monthly Magazine*. New Series, Vol. I. (1836).

Cooper, James F. *The Deer Slayer*. Philadelphia, 1841. Also, *The Path Finder*. Philadelphia, 1840.

Coplans, John. "Carleton Watkins and Yosemite." *Art in America*, 66, no. 6 (1978): 100–108.

Emerson, Ralph Waldo. *Nature*. Boston, 1836.

Huth, Hans. *Nature and the American*. Berkeley, California, 1957.

Jackson, John B. *The American Space*. New York, 1972.

Kozloff, Max. "The Box in the Wilderness." *Artforum*, 14, no. 2 (1975): 54–59. Also, *Photography and Fascination*. New York, 1979.

McSine, Kynaston. *The Natural Paradise*. Museum of Modern Art Exhibition Catalogue. New York, 1976.

Naef, Weston J., and James N. Wood. *Era of Exploration: The Rise of Landscape Photography in America*. New York, 1974.

Novak, Barbara. *Nature and Culture*. New York, 1980.

Olsen, Charles. *Call Me Ishmail*. New York, 1947.

Ostroff, Eugene. *Western Views and Eastern Visions*. Washington, D.C., 1981.

Parkman, Francis. *The Oregon Trail*. Boston, 1872.

Szarkowski, John. *American Landscapes*. New York, 1981. Also, *The Photographer and the American Landscape*. New York, 1963.

Tilden, Freeman. *Following the Frontier*. New York, 1964.

de Tocqueville, Alexis. *Democracy in America*. New York, 1838.

Wilmerding, John. *American Light: The Luminist Movement, 1850–1875*. National Gallery of Art Exhibition Catalogue. Washington, D.C., 1980.

Wister, Owen. *The Virginian*. New York, 1902.

The book was printed in brown and black duotones by Pepco Lithography of Cedar Rapids, Iowa.

It was bound by Nicholstone Bindery of Nashville, Tennessee.

The book was composed in Garamond #3 on a Mergenthaler Linotron 202 by Carolinatype, Durham, North Carolina.

It was designed and produced by Joyce Kachergis Book Design and Production in Bynum, North Carolina.